Wire Knits

Heather Kingsley-Heath

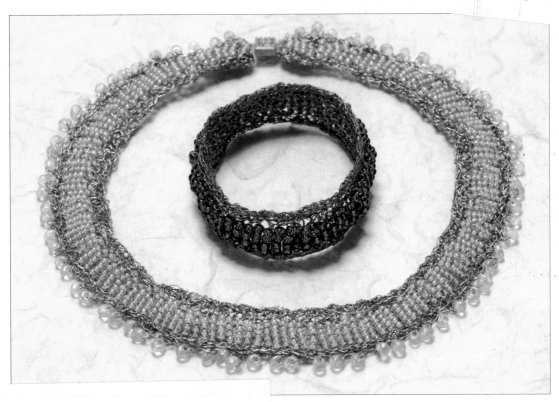

SEARCH PRESS

Acknowledgements

My thanks go to

The women of my family who taught me to knit and sew, and how to escape into the creative world of colour and imagination.

Himself for accepting that his wife never will get a 'proper' job, and for his tireless efforts to keep us afloat in our boat.

Kirstie for checking the technicalities of knitting patterns
Anne for not laughing at my spelling
Caroline for her tireless support
Kate for modelling and being beautiful
Katharine for being the kindest photographer
and to all my students who taught me how to laugh at myself, a lot.

First Published 2007

Search Press Limited
Wellwood, North Farm Road
Tunbridge Wells, Kent TN2 3DR

Copyright © Heather Kingsley-Heath 2007

Photographs by Katharine Lane-Sims

Photography and design copyright
© Heather Kingsley-Heath 2007

ISBN 10: 1-84448-224-3
ISBN 13: 978-1-84448-224-5

The Publishers and author can accept no responsibility for any consequences arising from the information, advice or instructions given in this publication.

Readers are permitted to reproduce any of the items in this book for their personal use, or for the purposes of selling for charity, free of charge and without the prior permission of the Publishers. Any use of the items for commercial use is not permitted without the prior permission of the Publishers.

WHAT YOU NEED TO KNOW — Get started

4 All Wired Up
6 Workbox Basics
8 How to Knit With Wire

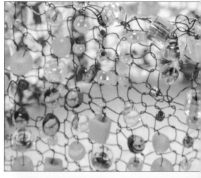

START KNITTING — Simple shapes

10 Candy Floss Cuff
12 Party Bracelet
14 Earth Angles
16 Peridot Angles
18 Droplet Lariat
20 Glamour Bag

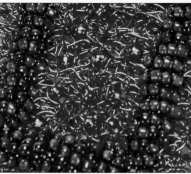

LAYER CAKE — Folded layers

22 Love Hearts
24 Folded Brooches
26 Beach Bangles
28 Talismans

FLOWER BOWER — Flower designs

30 Star Flowers
32 Spring Flowers
34 Rosebuds
36 Leafy Leaves
38 Pointy Leaves
40 Petal Flowers

CORD IT — Tubular knits

42 Secret Pearls
44 Beaded Braid
46 Layered Braid
48 Rainbow Lariat
50 Mi-Cord
52 Wide Cord

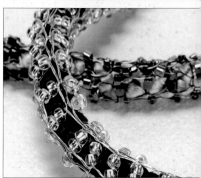

GO GIRLIE — Flounce and spirals

54 Fairy Collar
56 Lace Collar
58 Ruffles
60 Spiral Scarf

HELPFUL ADVICE — More about what you need to know

62 Healthy Advice
63 Terminology
64 Index

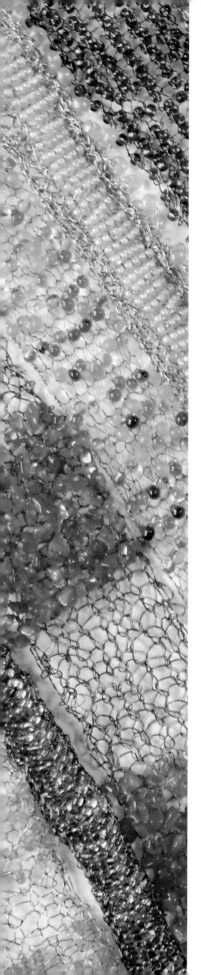

All Wired Up

knitting with wire is an ancient craft

My first memory of knitting is leaning on my grandmother's knee as her fingers, needles and yarn travelled at the speed of light to create a length of soft pretty fabric. I shall firmly date myself now by telling you that most of my winter woollies were home knitted. By the time I was a teenager I was knitting my own. I had varying degrees of success as I 'invented' my own jumper and cardigan shapes.

The best parts were the visits to our tiny local wool shop. It was a haven of colour with its floor to ceiling cubes of wooden shelving packed with yarn balls. There were fine four-ply yarns, single and doubles, Arans and occasionally a fancy yarn. Planning a project consisted of choosing the yarn with most colours in the range and buying one ball of each colour.

The selection of yarns and threads now available to knit with is heavenly in its abundance. New designers are taking all the best aspects of the old craft and adding creative innovation. There are knitting clubs and web blogs, knitting shows, events and exhibitions, all of which have the most inspiring array of knitting.
Most exciting of all is the welcome reappearance of those wool shop havens in many small towns and high streets.

New knitting truly encompasses the experimental. As long as it resembles a thread we will attempt to knit with it. Knitting with wire is just one of these knitting adventures. Craft wire is now available in a whole range of gauges and colours, yet another new form of gently gleaming coloured thread to play with.

After some initial experiments with the different thicknesses I discovered that by using the finer wires, the actual process of knitting becomes very easy and the fabric produced is both delicate and durable. Once I had accepted the fact that wire and yarn behave very differently it was easier to concentrate on the possibilities that fine wire presents.

Knitted wire is surprisingly strong as a fabric. It will take some stitch patterns but many do not show significantly. It can be folded, layered, pleated and stitched. Best of all, it can be embellished with beads and enhanced with delicate threads. Wire is a wonderful 'yarn' to knit with. You can blend several strands to add depth to the colour, and because it holds its shape you need never go chasing back though your knitting for a dropped stitch!

Originally, metal wire was made by cutting fine strips and rolling them into a tube by pulling the wire strip through a hole in a stone bead. The seam formed as the strip was rolled would spiral along the length of the hollow wire adding strength. In Egyptian and early European Bronze and Iron Age jewellery, square wire was often used. It was formed by hammering metal into a groove. Square wire was often twisted to make a decorative spiral. By the seventh century true drawn wire was being produced, this process involved taking a piece of metal, heating it up, then drawing it through ever decreasing holes until it had reached the desired diameter. Draw plates, the hardened metal, (or in some cases drilled rubies or diamonds), with holes to accommodate the wire, could have round, square or D-shaped holes. Surprisingly the making of drawn metal wire didn't reach England until around the seventeenth century and was first used in the iron industry.

If you have ever tried jewellery making or metal smithing you will know that heated metal, once it has cooled, remains pliable. If you want it to harden and hold its shape it needs to be annealed. This process gives us different types of wire hardness. The copper wires we know as craft wires have been hardened, and then coated with a plastic or enamel laquer to add all those gorgeous colours. Even though the wire is very fine the hardening process is important to enable the wire to hold whatever shape is chosen. The coatings are fairly robust but can scratch or rub off. They will not come off as you knit, but they may rub off the surface of jewellery eventually.

From the Industrial Revolution onwards wire production has become increasingly technological. It is now possible to make wire as fine as a cobweb. Industry uses a lot of these fine-knitted wire fabrics, mostly for filters. Gossamer-thin wires are machine knitted or woven into fabrics that drape as fluidly as silk. Craft suppliers have raided the industrial store cupboard on our behalf, and it now is possible to buy these ready-knitted wires as fine tubular ribbons in different widths.

But we want to knit with wire ourselves, so here are some tips for securing the best wire for the job:
Wire thickness is measured by gauge. There are several gauge systems in use, developed over time in the UK, Europe and the USA. This can be confusing, but here we are only concerned with two thicknesses. Any thicker and the wire will be too tough to knit with; any thinner and it will be too frail, snapping frequently and not holding a shape.

Wire is readily available from craft shops. Alternatively, if you have difficulty obtaining any of the materials mentioned in this book, they are available by mail order, via the Internet. Wire sometimes comes on spools of 175m (191yd) which are fairly inexpensive and a mm gauge is occasionally used to indicate the thickness. Other gauges are, SWG (Standard Wire Gauge), or AWG, (American Wire Gauge).

WIRE GAUGES		
MM	SWG	AWG
0.200	36	32
0.315	30	28

Workbox Basics

there is much pleasure to be had
from working with good tools

Knitting with wire can be as easy as knitting with fine yarn, or an agonising process that is tough on the hands, it all depends on the wire you select. The wire is supplied on spools and it can unravel at an alarming rate. It helps to put the spool in a plastic bag with the reseal strip, the wire stays under control and it helps prevent wires tangling with each other if you are using more than one colour.

How much wire? One 175m (191yd) spool of gold coloured wire was enough to work the talismans on page 28, the leaves on page 36 and the scarf on page 60. Wire colour, like all batch dyed materials, can vary so if you are planning to knit a lot buy several spools at the same time, just as you would with yarn.

Scissors

Buy yourself a pair of inexpensive craft scissors and keep them just for snipping wire. Although the wire is very fine, having 'wire dedicated' scissors will stop you blunting your best sewing scissors.

Knitting needles

You can use metal, wooden, bamboo, or plastic needles for knitting with wire. For the projects I used 2.75mm, 3mm, 3.75mm and 4mm needles. Just like knitting with fine yarn you will achieve better results by using a smaller gauge of needle.

NEEDLE GAUGES		
Metric	**Old UK**	**USA**
2.75mm	12	2
3mm	11	use 2 or 3
3.75mm	9	5
4mm	8	6

Fancy accessories

Row counters are little numbered gadgets that you attach to the end of the needle, changing the number by hand as you knit to keep count of the rows.
Row markers come in an assortment of dinky designs, but are basically split wire links you can attach to a stitch to mark your place, removing them later.

Hand cream

Some knitters swear by liberal amounts of hand cream. I find it makes everything slide about more than necessary so I just use it as a treat after a knitting session.

Yarns

Having explored knitting with one or two strands of wire you may want to add variety by including some fine threads. Adding a thread will give your wire knitting a little more body, texture and lots more colour and sparkle possibilities. Have fun looking in the embroidery department for the following:-

Sewing cotton

Regular sewing cotton used straight off the reel will add colour and a matt texture to your knitting, use one or more strands to add thickness.

Blending filament

Fine metallic sparkly threads originally intended to be added to strands of embroidery thread. It works just the same when added to wire for knitting. Blending filament is available in ranges of metallic, pearlised and irridescent finishes.

Metallic braids

These are slightly thicker braided threads which will add a lot of body and sparkle to your work. They will also bulk out your wire knitting, making it softer and less able to be bent into shapes.

Fancy threads

Novelty threads are great fun to play with; they range from hairy to fluffy, some have interesting slubs and all come in a dazzling array of plain or variegated colours.

Beads

Adding beads to wire knitting is a natural extension of the technique. Beads are threaded on to the wire before you start knitting. Gather an assortment of seed beads in different sizes, triangle beads and crystal chips. Sequins, pearls and random mixes of beads also work well with wire knitting. There are lots of bead shops and Internet retailers offering mail order, all of whom will happily help you identify the different bead sizes and types available.

Pliers

Many of the designs use clasps, and to attach these it helps to have a pair of round-nosed pliers and a pair of flat-nosed pliers with a cutting section. Widely available, these small hand tools will make light work of fixing metal findings, or bending and cutting thicker wire to make your own findings.

Findings

Clasps, closures, brooch backs and hairslide bases all come under the neat heading of findings. If you cannot find an exact match to the clasps used in the photographs, you will certainly be able to find a near relative.
Most craft and bead shops stock a range of findings. Also handy to have in your toolbox are an assortment of jump rings. These are small metal rings that you can open and close; they make a neat link between your finished work and the clasp allowing everything to move happily as you wear your designs.

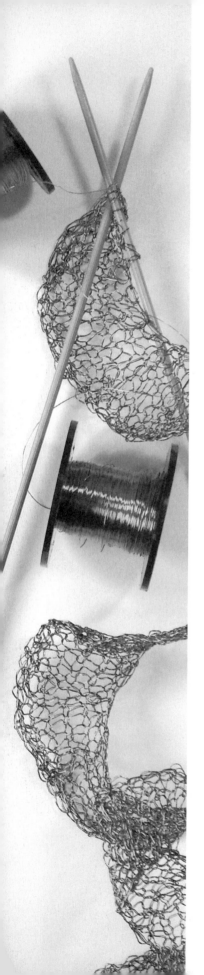

How to Knit With Wire

wire is not yarn but you use the same stitches

I have taken the bold step of assuming that you already know the basics of knitting. If you are a keen beginner then there are books that will teach you how to cast on, knit, purl and cast off. This information is also readily available in the back of knitting magazines or you can log on to one of the millions of knitting websites online.

Knitting with wire is just not the same as knitting with any other yarn. Wire does not stretch, and when it bends, it stays bent. However, knitted wire does create a wonderful maleable fabric in its own right. But first, you need to throw out all your preconceptions about knitting.

Take a deep breath and accept that knitted wire will never look neat and tidy. Knitted stitches stay the same size you made them. Once you have accepted this relax, because knitting with wire is great fun.

Working the wire

Most of the designs use a very fine wire at 0.200mm or 0.315mm thickness (see gauge chart on page 5). Wire this fine is surprisingly strong and flexible. Its one weakness, when compared to yarn, is that it will snap if it is allowed to kink over on itself. Smooth out any loops in unknitted wire before the wire gets to this stage. If your wire does break, or if you need to join a new length, the method for rejoining wire is simple. Take the two tail ends of old and new wire, and twist them together. Four or five twists on the last centimeter (½in) of wire is ideal. Fold the twisted section over so that your old and new wire form a continuous length again. Carry on knitting, the twisted section may need a little coaxing through your stitch, but once worked it will be hidden within the knitting.

The stitches

Because wire is obedient and will hold whatever shape you bend it into, you need to work the wire a little more carefully than you would a stretchy yarn. When forming a stitch you will have to actively slide the old stitch off the needles. It becomes a habit very quickly. When you have formed the new stitch, you will need to pull the wire gently so the new stitch fits snugly on the needle. Do not pull too much otherwise it will be a hard job to get both needles into the stitch on the next row. If you force it, the stitch can burst as the wire will snap under pressure. The stitches at the ends of rows can be over large so many of the designs compensate for this by asking you to slip the first, or last stitch of each row.

Smoothing out

Yarn has stretch in it, which is why you are asked to work a tension square before knitting a pattern. The tension square enables you to approximate the same tension on your yarn as the original designer used when the pattern was first knitted. There are no tension squares with knitted wire. Instead, all you need to do is make sure your stitches fit reasonably snugly on the needles. Finished knitting in yarn will be plump and springy; if you pull it, it will bounce back into shape. Finished wire knitting is usually a bit scrunched up and needs smoothing out. To smooth out simply pull gently until all the stitches open out, and the sides and ends become straight. The wire knitting will stay exactly as you leave it.

Wire ends

The ends of wire are scratchy and can really prickle. Fold the very tip of the wire end over and pinch together. Then weave the wire end into your knitting to bury it out of the way.

Multiple strands

Lots of the designs call for you to use two or more strands of wire, or wire and a fine thread. Bring the strands together and treat them as one thread. As you knit smooth the strands together so that they lie neatly. Adding a thread can cause some stitches to have larger loops of thread, because the thread is more flexible than the wire. Just check your knitting occasionally and tweak the thread into place as you work.

Adding beads or other embellishments

All the beads are threaded on to the wire before you start knitting. It helps to thread the end of the wire on to a needle. Check the needle will pass through the bead holes. The wire in the needle will snap eventually, just re-thread and keep going. When you are using beads it is only necessary to thread them on to one wire, even if you plan to knit with more than one wire or a wire and a thread. The exception to this rule are sequins or any flat disc shape; for these you will have to take the time to thread them on to all the wires/thread you plan to knit with.

The pain factor

Lots of knitters are put off knitting with wire because they have heard that it is painful! Knitting with wire is inevitably tougher on the hands, and you do have to move your fingers about a bit more to manipulate the wire than you do with yarn. But the fine-gauge craft wires are a lot softer to work with than earlier versions.

If you have developed the habit of looping yarn over spare fingers to help you with tension, you may find that the wire will create an uncomfortable groove. There is no need to hold the wire under tension as it does not stretch.

The simple solution to avoiding wear and tear on your hands is to resist the temptation to knit intensively. Instead, limit your wire knitting sessions to give your hands time to rest. If you just have to keep knitting, have a yarn project on the go so that you can chop and change between the two.

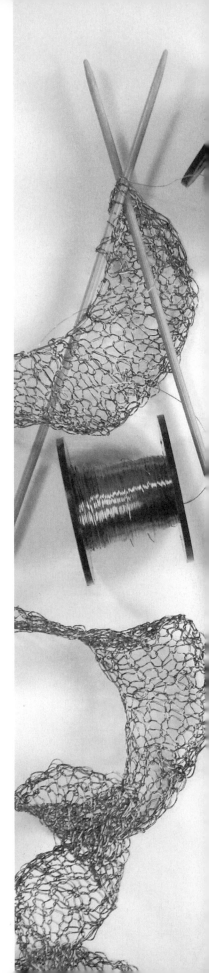

Candy Floss Cuff

get knitting with wire and beads to create a simple cuff

For each project I give approximate bead quantities and the gram weight of beads.

For this pretty cuff I use a mixture of beads up to 4mm diameter. I do not give exact lengths of wire, as one spool will easily knit several of each project.

Thread all your beads on to the spool of wire. If it helps you can thread the wire end on to a needle. Make sure, as you add the beads, that the wire does not bend or kink. Remember, kinks can cause breaks and this can be frustating if you have to re-thread all your beads.

As you knit you will need to keep pushing the beads down the wire to release more wire to knit with. Beads in knitting are actually on the wire that sits between two stitches. Knit the first stitch, slide one bead right up to the back of this stitch, then knit the next stitch. Repeat the same process for the next stitch, and so on. It really is that easy.

As you knit keep the stitches even by pulling the wire gently once a stitch has been worked. It soon becomes a habit.

START KNITTING HERE

Thread all your beads on to the wire.
Cast on twelve stitches.

Row 1: Knit.
Row 2: Slip (sl) the first stitch, then slide the first bead up. Knit 1, slide bead up. Repeat to the end of the row.
Row 3: Sl1, knit remaining stitches.

Repeat rows 2 and 3, remembering to slip the first stitch of each row.
When you have 41 beaded rows, end on a knit row and cast off.
Leave a 20cm (7¾in) tail.

Smooth out your knitted piece so that it forms an even-shaped rectangle, then stitch it together (see opposite).

If your cuff is too big, pull the edges to lengthen the rows and reduce the diameter. Alternatively, if it is a bit small, you can stretch the cuff the other way.

MATERIALS
15g (½oz) mixed beads (465 beads)

3mm knitting needles

0.200mm wire: pink.

Tapestry needle (size 26)

Scissors

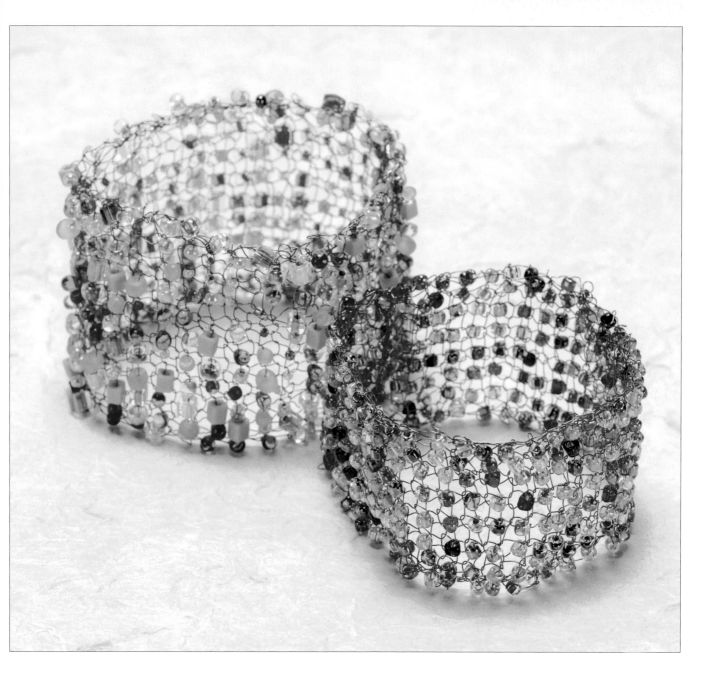

Stitching the cuff *Finished size, diameter approximately 20cm (7¾in)*

Bring the two short ends of the cuff together and line them up. Use the tail of wire and stitch through the two edges of your knitting at the corner. This will anchor the two edges together (see diagram).

Thread a bead on to the wire and pass the wire through the opposite edge.
Bring the wire under both edges and back through the first edge.
As you stitch add one bead per stitch and line up each stitch with a knitted stitch on each edge. This will create one more beaded row and hide the join.

Finish off the wire tails by threading them through your knitting.
Snip off the remainder, fold the tip of the wire, then bury it in your knitting.

Party Bracelet

add beads every row for a bead encrusted bracelet

More beads, more colour! By knitting beads on alternate rows, all the beads sit on one side of your knitted fabric. By adding beads to every row knitted, the beads will sit on both sides of the fabric giving you a dense texture of beads and wire. The 0.315mm wire used here is a slightly thicker wire. It works into a chunkier fabric which will still be soft and fexible. It's not too hard on the hands either.

Silver-lined beads are beads that have a coating of silver along the inside of the hole. The silver sparkles through the clear glass bead, catching the light as the beads move. The bling effect is more intense with paler colours of the glass beads.

The bar clasp is a fold of metal that you can slide your knitted ends into, then pinch tight with pliers. The bar clasp will hold your knitting firmly in place.

MATERIALS

15g (½oz) size 8 silver-lined seed beads (390 beads)

3mm knitting needles

0.315mm wire: dark blue

Bar clasp

Flat-nosed pliers

START KNITTING HERE

Thread all your beads on to the wire.
Cast on six stitches.

Rows 1 – 4: Knit.
Row 5: Sl first stitch only, slide bead up, k1, slide bead up, k1, repeat to end.
Repeat row 5 until you have knitted 62 rows.
Remember to slip the first stitch of each row.

Rows 67 – 69: Knit without beads.
Row 70: Cast off.

Smooth out your knitting so that it forms a neat oblong. Do not worry if one or two beads have moved around within the knitting. It is an easy job to slide them back in place, then pinch the wire stitches to hold them there.

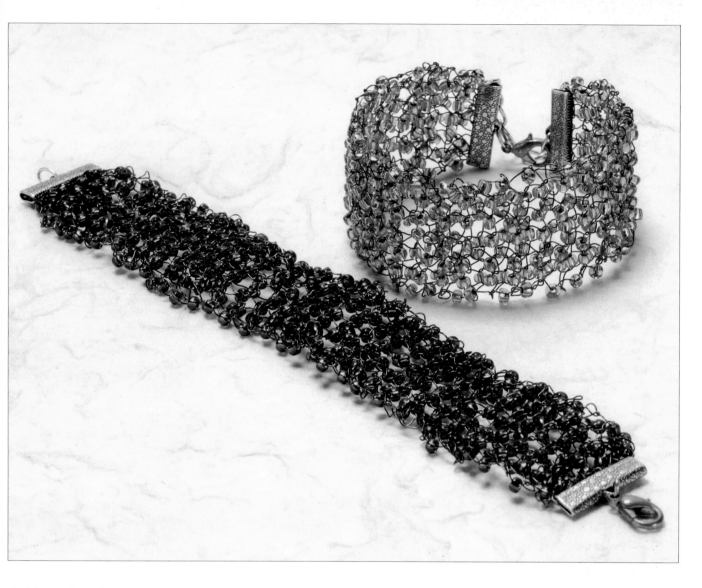

Adding the clasp *Finished length including clasp 19.5cm (7 ¾in)*

Work the tails of wire back into the ends of your knitting.

Take one end of your knitting and smooth, then fold and shape it until it is just slightly narrower than the bar clasp.

Slide the folded end into the bar clasp, make sure it is right in as far as it will go (see diagram). With flat-nosed pliers, pinch the flat sides of the bar clasp together so they grip and hold the knitted end in place.

Repeat with the other end of your knitting and the other section of the clasp.

Some bar clasps come with the bonus of a safety chain. To attach the chain, open the end link by twisting the two ends sideways. Thread the link into your knitting next to the clasp, then close the link by twisting the two ends back together. Repeat with the other end of the chain and the other side of your knitted bracelet.

The safety chain should be long enough for you to be able to put the bracelet on before closing the clasp, but short enough to stop the bracelet falling off should the clasp come open.

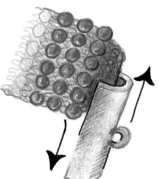

Earth Angles

crystal chips floating on a bed of knitted wire

Crystal chips are usually sold already threaded on to cotton. These hanks of chips are relatively inexpensive and an ideal companion to wire knitting. The design uses two strands of 0.200mm wire. It is easier to knit with two fine strands than with one thicker one. Using two strands also means you can add depth to your design by mixing colours. You only need to thread the crystal chips on to one of the wires. It is too fiddly to try and get both wires through all the chips. As you knit the two wires will sit together.

This necklace is knitted in two parts and then stitched together at the front, giving a richly coloured centre point to your necklace.

MATERIALS

128cm (50½in) carnelian stone chips (640 chips)

3mm knitting needles

0.200mm wire : vivid red, mid brown

Round-nosed pliers

Large toggle clasp

2 jump rings or 10cm (4in) thick wire

Tapestry needle (size 26)

START KNITTING HERE

Thread all your crystal chips on to one of the wires.
Use two strands of wire and cast on ten stitches.

Plain section
Rows 1–16: Sl1, knit remaining stitches.

Crystal chip section
Row 17: Sl1, add chip (k1, add chip) repeat to end of row (ten chips).*
Row 18: Knit.
Repeat rows 17 and 18, eight more times.
* To have ten chips you will need to slide one up at the end of the row before you start the next knit row.

Knit a plain section, then a crystal chip section, three more times.
Knit one plain section then cast off.
Repeat to knit the other side of the necklace.

Sew it together
Smooth out your knitting so that all the edges are straight.

Lay the two knitted end sections over each other at right angles.
Sew them together with one strand of wire (sewing layers, see page 24).
Oversew the edges of the knitting to neaten them (oversewing, see page 19).
Fold the other ends of the necklace sections over into a triangle, compressing your knitting until you are satisfied with the shape.

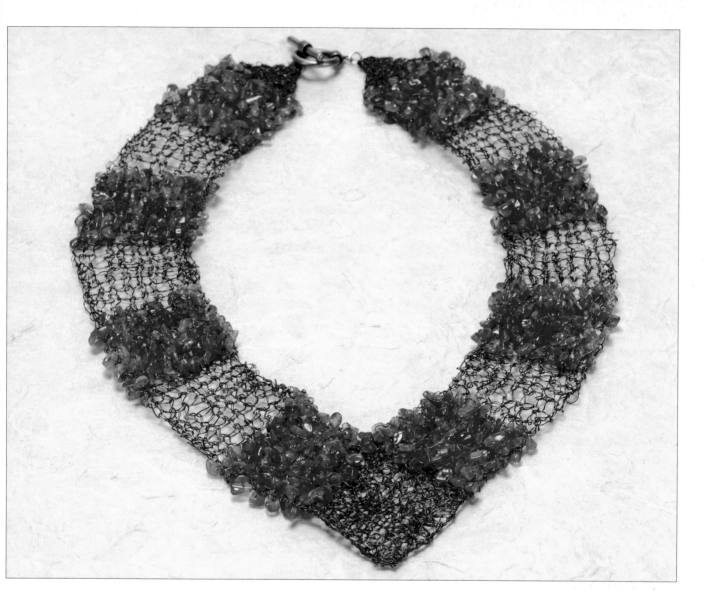

Adding a toggle *Finished length, inside edge, including clasp 56cm (22in)*

Take a 5cm (2in) length of thicker wire and bend it with round-nosed pliers
into a figure of eight shape (see diagrams A and B).

Slide one section of the toggle clasp on to one of the loops, then bend the wire
to close the loops.

Insert the figure of eight into your triangle of folded knitting and sew it into
place with fine wire (see diagram C). The loop with the toggle attached should
stick out of the triangle point. Repeat on the other end of the necklace with
the other section of the toggle clasp, and a second figure of eight shape.

If bending wire is too fiddly for you, you can use jump rings to attach the toggle
instead (see page 17 for instructions).

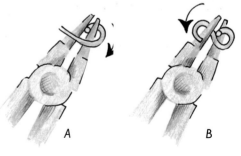

A B

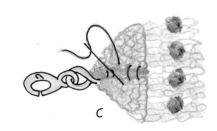

C

Peridot Angles

more fun with crystal chips

This floating crystal necklace has a little embellishment to add character. It is just as simple to knit and construct as the Earth Angles necklace on the previous pages. The design is knitted as one long piece and folded in the centre. Because adding chips on alternate rows places the chips on only one face of the knitting, you will need to check that the second section has them on the other face. When you fold the necklace in the middle all the chips will appear on the front.

MATERIALS

128cm (50½in) peridot stone chips (384 chips)

3mm knitting needles

0.200mm wire: silver, leaf green

Silver toggle clasp

14 jump rings

Round-nosed pliers

12cm (4¾in) fine chain, 2cm (¾in) sections

6 x large droplet beads

Tapestry needle (size 26)

START KNITTING HERE

Thread all the peridot chips on to one of your wires.
Use two strands of wire and cast on seven stitches.

Plain section
Rows 1–9: Sl first stitch, knit remaining stitches.

Crystal chip section
Row 10: Sl1, add chip, k1, add chips to end of row (6 chips).
Row 11: Sl1, knit remaining stitches.
Repeat rows 10 and 11, four times.

Knit one plain section, then one crystal chip section, seven times.

Centre section
Knit 36 rows without crystals.
To work the other side of the necklace, start with one crystal chip section, followed by one plain section. Check to make sure that the crystal chips lie on the reverse side of your work for this section.
Knit seven more chip and plain sections, ending with a plain section.

Sew it together
Smooth out your knitting and make sure the edges are straight.
Take the centre section and fold it once.
Align the two crystal chip sections so that they meet at the point where the fold crosses over (see photograph opposite).
Stitch the fold in place with one strand of wire (see sewing layers, page 26).
Fold each end section of plain knitting into a neat triangle and stitch in place.

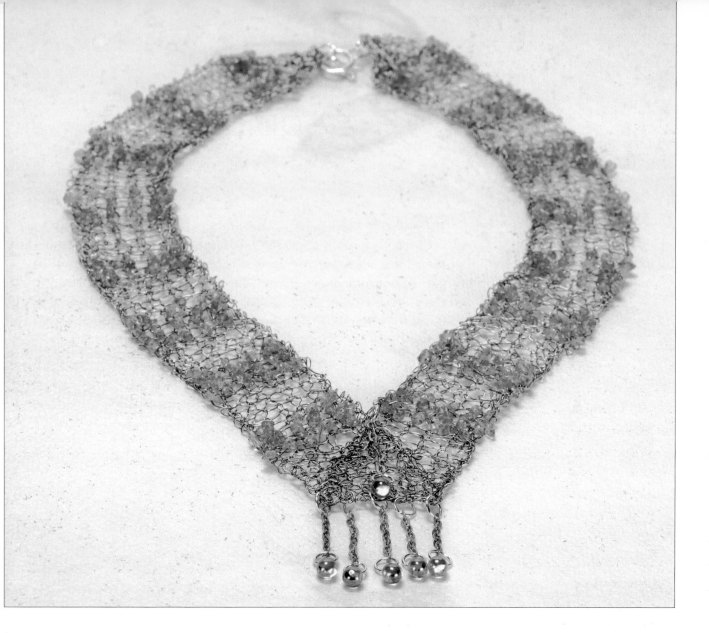

Adding the finishing touches

Finished length inside edge, including clasp 54cm (21¼ in)

Take a jump ring and open it by twisting the two ends sideways away from each other with your round nosed pliers. It helps to use two pairs, one for each end of the jump ring (see diagram A).

Thread one end through the tip of your folded triangle (see diagram B).

Then slide one of the clasp sections on to the jump ring.

Close the jump ring by twisting it back together again.

The dangly bits are short sections of fine chain (look in the broken jewellery pile or a local junk shop). Each section of chain has a jump ring on both ends, one to attach to the necklace, and one to attach a droplet bead.

To add a droplet, thread it on to one of the jump rings, thread the jump ring on to a chain, then pinch the jump ring closed.

Attach five chain sections to the flat edge along the bottom of your folded necklace, and one to the top of the folded section.

A

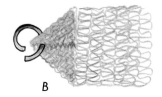

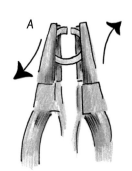

B

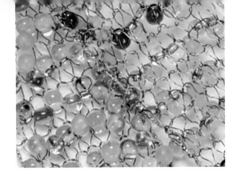

Droplet Lariat

wrap it, tie it and wear it with flair

The mini droplet beads used in this lariat glow as they catch the light. The design is a simple band with pointed ends that you can wear like a scarf, a tie or a lariat. Knitted with one strand of wire, the delicate fabric is protected from wear and tear with a metallic thread edging. The sample is in shades of lemon, lime and green, with the darker beads threaded mostly at one end, so that the lariat appears shaded from dark to light once knitted. Droplet beads are available in a huge range of colours and finishes, so just pick out your favourites and get knitting.

MATERIALS

60g (2⅛ oz) droplet beads (1031 beads)

2.75mm knitting needles

0.200mm wire : leaf green

Metallic thread: Coats Reflecta colour 0313 or similar

Tapestry needle (size 26)

START KNITTING HERE

Thread all the droplet beads on to your wire.
Use one strand of wire and cast on two stitches.

Row 1: K1, add bead, k1.
Row 2: Inc1, inc1 (4).
Row 3: K1, add bead, rep to end, k1.
Row 4: Inc1, k2, inc1 (6).
Row 5: K1, add bead, rep to end, k1.
Row 6: Inc1, k4, inc1 (8).
Row 7: K1, add bead, rep to end, k1.
Row 8: Inc1, k6, inc1 (10).
Row 9: K1, add bead, rep to end, k1.
Row 10: Knit.

Repeat rows 9 and 10, 110 times,
ending with a beaded row.

To decrease at the other end:
Row 231: K2tog, k6, k2tog (8).
Row 232: K1, add bead, rep to end, k1.
Row 233: K2tog, k4, k2tog (6).
Row 234: K1, add bead, rep to end, k1.
Row 235: K2tog, k2, k2tog (4).
Row 236: K1, add bead, rep to end, k1.
Row 237: K2tog, k2tog (2).
Row 238: K1, add bead, k1.
Row 239: Cast off remaining two stitches.

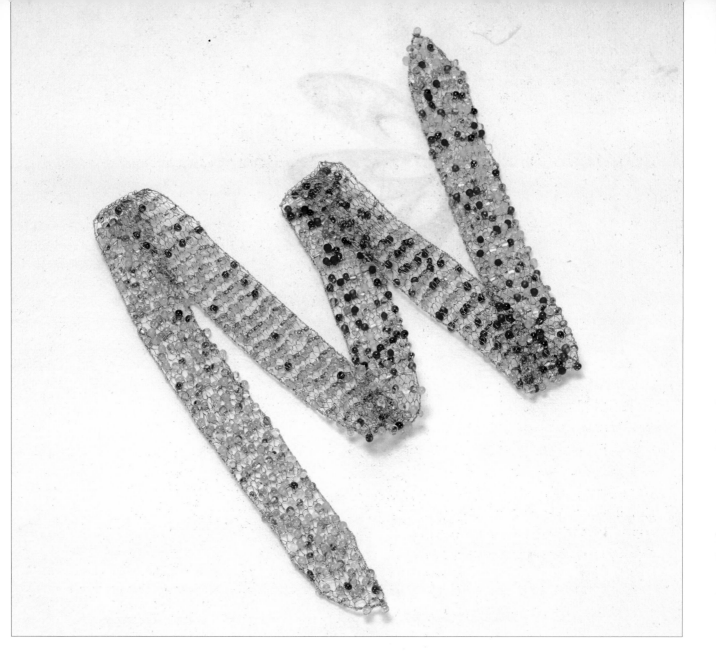

Oversewing the edges

Finished length approximately 87cm (34¼in)

Smooth out your knitted piece, making sure that the edges are straight. Thread your metallic thread on to a tapestry needle and attach both thread ends to the edge of your knitted piece with a small knot. Fold the thread ends along the edge of your knitting in the direction you plan to work, then oversew the edge, making sure the wire is covered with thread (see diagram).

Oversewing is simply wrapping the thread over the wire along the edge of your knitting. When you have covered about 1cm (½in) of the thread ends, snip off the tails. Keep sewing until all the edges are covered.

To start a new thread, knot the old thread where you finish stitching, then tie on a new thread as before. Oversew both the old and new ends for 1cm (½in), then snip off the remaining tails.

Glamour Bag

beads are great but what about sequins?

Knitted wire makes a light airy fabric; the bigger the needles the more open the fabric will be. When knitting with sequins, you need big stitches to allow the sequins room to sit flat in your knitting, so that they look pretty. The bag starts as two squares of knitting: one with and one without sequins. To complete the bag all you need are two squares of felt and a length of French knitting for the handle.

MATERIALS

4g (⅛ oz) square sequins (1,144)

4mm knitting needles

4-pin French knitting dolly

0.200mm wire : pink

2 pieces of felt, pink
16 x 16cm (6¼ x 6¼ in)

Sewing thread and needle

Tapestry needle (size 26)

Scissors

START KNITTING HERE

Thread 1,004 sequins on to your wire.
With one strand of wire cast on thirty stitches.

Row 1: Knit.
Row 2: K1, add sequin, rep to end, k1.

Repeat rows 1 and 2 for 34 rows.

Row 37: Knit.
Row 38: Cast off.

The back section of the bag is knitted in the same way, but without the addition of sequins (this makes for a smoother finish against your party dress).

Smooth out both your knitted sections until they form neat squares.

Party bag strap
Thread 100 sequins on to one strand of pink wire.

With two strands of pink wire (one with and one without sequins), work on a 4-pin knitting dolly and make a length of French knitting 140cm (55⅛ in) long. (See page 42 for French knitting on a dolly instructions. For adding beads, see page 44.)

Add a sequin every now and then as you work. The sequins will slide inside your knitting, which is fine. They will glint from within.

Pull the French knitting smooth and flatten it.
Fold the French knitting in half and twist it into a rope, flattening it as you work.

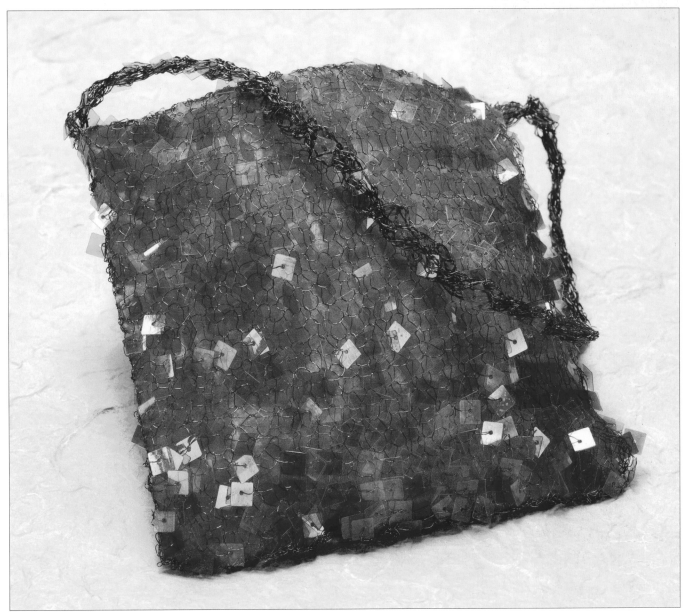

Making the party bag

Finished size approximately 16 x 16cm (6¼ x 6¼in), handle 46cm (18in)

Cut two pieces of pink felt so that they are the same size as your knitted squares.
With pink sewing thread oversew three edges of the felt together to form a bag.
Then place the two pieces of knitting together (sequin side out) and oversew three
edges together using one strand of pink wire (see diagram A).

A

Slide the felt bag inside the knitted bag and oversew the top edges with sewing thread,
to form the bag opening and to join the sections together (see diagram B).

Stitch the side and bottom edges together if you feel they need anchoring.
Insert one end of the French knitting into the side of the bag opening and sew it in place
(see diagram B). Repeat on the other side with the other end of the French knitting.

B

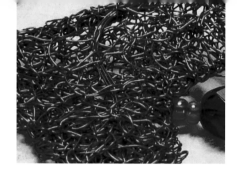

Love Hearts

not all knitting has to have beads on

Now that you have explored the possibilities of flat knitting and knitting with beads, it is time to move on. Knitted wire can be bent, folded and layered and will happily hold any shape you form it into. Folded knitted wire also creates a rich and dense textured fabric which is very strong. You can use this folded fabric to construct and mould shapes. The techniques in this section are simple, with lots of scope for experimentation and adding your own creative ideas.

These love hearts illustrate the basic idea of folding. You start with a square that is quick to knit, then fold and fold again until you have a triangle, then you can nudge the edges into a cute heart shape.

MATERIALS

3.75mm knitting needles

0.200mm wire: vivid red

Tapestry needle (size 26)

I pair earring findings

I pair head pins

2 jump rings

2 crimp beads

32 red seed beads

8 red crystal beads or similar

I necklace clasp

Beadalon bead stringing wire or similar

Flat-nosed pliers

Round-nosed pliers

START KNITTING HERE

With one strand of wire cast on fifteen stitches.

Row 1: Knit.
Row 2: Knit.
Repeat until you have worked 20 rows.
Row 21: Cast off.

Make two squares for the earrings, five for the necklace.

Forming the hearts
The diagrams below illustrate how to form each of the textured hearts. The instructions are opposite.

Before you start, choose one of the knitted squares and smooth it out so that it is flat, then follow the diagrams, left to right.

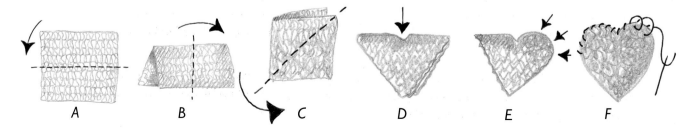

A B C D E F

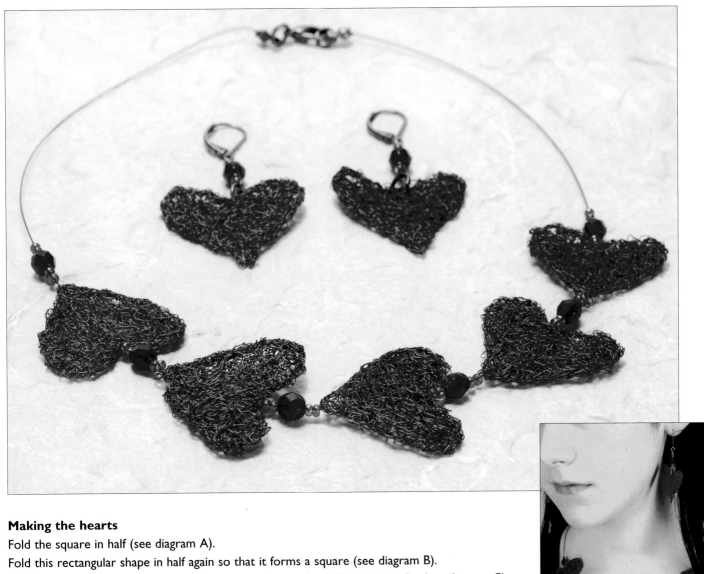

Making the hearts

Fold the square in half (see diagram A).

Fold this rectangular shape in half again so that it forms a square (see diagram B).

Fold the square diagonally to make a triangle and press the folded knitting flat (see diagram C).

To shape this triangle into a heart, make a dent in the centre of the folded edge (see diagram D).

To shape the heart, gently compress the two top corners into rounded shapes, then neaten the other point of the triangle (see diagram E).

Oversew the edges with red wire to hold all the layers together (see diagram F).

Making your earrings and necklace *Finished length including clasp 50cm (19¾in)*

Cut a length of beading wire, and at one end thread on a crimp bead and a jump ring, with one half of the necklace clasp attached. Pass the wire end back through the crimp bead and pinch it flat with the flat-nosed pliers. The crimp bead is designed to be flattened and to hold the beading wire safely in place instead of a knot. Snip off the wire tail. Thread on your crystal beads, and hearts, threading the beading wire between the layers of each heart. Finish off the other end of the beading wire with a second crimp bead, jump ring and the other half of the necklace clasp.

To make one earring thread the beads and a heart on to a head pin, fold the top of the pin over, with round-nosed pliers, to form a loop, then attach the loop to your earring finding. (see page 15 for instructions on how to bend wire). Repeat the process for the second earring.

Folded Brooches

luscious layers and sparkly beads

Folded wire knitting can be as dense or as airy as you like. Each layer adds more texture and greater strength to your work. These sparkling brooches start as a rectangle of knitting that is folded into quarters. After binding the edges all the layers are stitched together, giving you the perfect base to add embellishments.

Choose two colours and textures of seed beads to either complement or contrast with your chosen wire colour.

MATERIALS

10g (³⁄₈ oz) size 11 seed beads in two colours

3.75mm knitting needles

0.200mm wire: one colour per brooch: supa violet, dark slate, pink, vivid red

Tapestry needle (size 26)

Beading needle (size 10)

1 brooch back per brooch

Beading or sewing thread to match wire colour

START KNITTING HERE

Use one strand of wire and cast on twenty stitches.

Row 1: Knit.
Row 2: Knit.
Repeat rows 1 and 2 until you have worked 40 rows.
Row 41: Cast off.

Forming the brooch base
Smooth out your knitted rectangle. Fold it in half making sure the edges line up. Fold it in half again (quarters), once more lining up all the edges.

When you are happy with the shape, thread a length of wire on to a tapestry needle and oversew all the edges to neaten them.

Sewing the layers together
With a length of wire make small random stitches all over the surface of your brooch base, bringing the needle from front to back and to the front again.

Adding the brooch back
Take one strand of wire and wrap the back of the brooch until it is neatly covered. Line up the brooch back on your base, with the pin open, about 5mm (³⁄₁₆ in) from the top edge. To stitch it in place (see diagram A opposite), start at one edge, pass the wire over the brooch back and through the base to the front, then bring it back through to the base, a little way to the side of the last stitch. Repeat this, making long stitches to hold the pin in place and small stitches on the front of the brooch. These smaller stitches will disappear into the texture of your knitting. Close the brooch pin, and make sure that as you add the bead decoration, your thread does not catch or wrap around it.

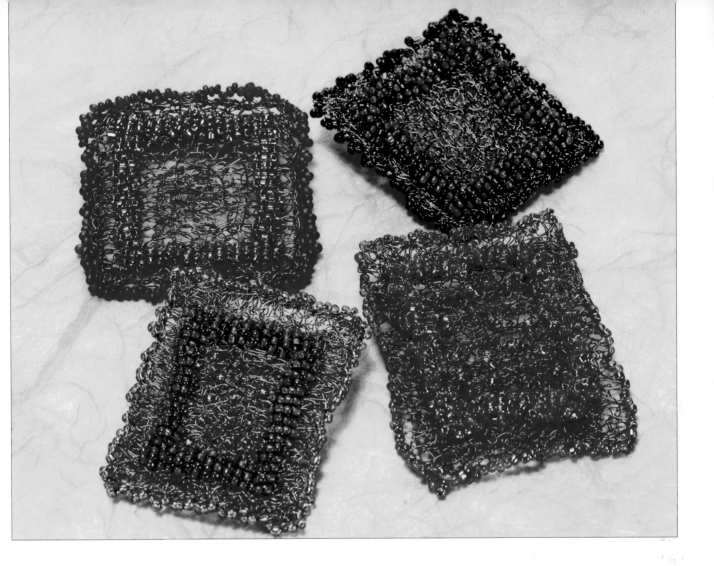

Adding beads *Finished size approximately 5 x 6cm (2 x 2¼ in)*

Beaded edging: attach a length of beading or sewing thread to the edge of your brooch, and thread on a beading needle. Pick up three seed beads and oversew the edge, making sure the stitch is the same length as the space used by the three beads (see diagram B). Repeat until you have added a beaded edging right round the edge of your brooch, then finish off the thread tails.

Beaded border: bring the needle and thread out of the front of the brooch just above the position of the brooch pin. Pick up three seed beads and make a stitch the same length as the beads, passing the needle from front to back just below the brooch pin (see diagram C).

Bring the needle out to the front again a little way to the side of the last stitch and add three more beads, securing the stitch at the top of the brooch pin. This will make sure the pin is covered from the front.

Carry on until you reach the turning point, about 5mm (³⁄₁₆ in) from the edge. The first side stitch lines up underneath the last few stitches of the top row. Repeat until all four sides are beaded. You can then add a random scattering of beads in the centre.

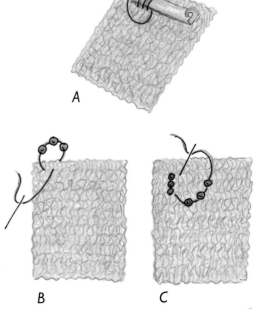

A

B C

Beach Bangles

one size fits all, any colour you like

Layered wire knitting is strong and can be folded into useful accessories. These beach bangles begin as a long strip of knitting which is folded and stitched into a layered bangle shape. This creates a great surface that is just waiting to be adorned with beads and colour. The bangles will hold their shape quite happily, plus they have enough flexibility to enable them to slide easily over your hand on to your wrist.

MATERIALS

10g (⅜ oz) size 11 seed beads in 2 colours to match or contrast your wire colour

3.75mm knitting needles

0.200mm wire: one colour per bangle, supa green, pink, dark purple, vivid red

Tapestry needle (size 26)

Beading needle (size 10)

Beading or sewing thread to match wire colour

START KNITTING HERE

Use one strand of wire and cast on thirty stitches.

Row 1: Knit.
Row 2: Knit.
Repeat rows 1 and 2 until you have worked 60 rows.
Row 61: Cast off.

Forming the bangle

Smooth out your knitted rectangle, making sure the edges are straight.
Fold one edge over and position it so that one third of the rectangle remains uncovered, then fold the other edge over (see diagram A). Move the knitting about until the edges are lined up.
Bring the short ends together, and secure them with stitches to form the bangle shape. Make sure you stitch through all the layers.
Now make small stitches from front to back, and back again, stitching all the layers together (see diagram B). Use random stitches all over the surface of your bangle.

At this stage it is easy to adjust the diameter of your bangle. If it is too big, pull the stitches up tight as you work to bring the knitting closer together. If it is the right size already, then make sure to keep the stitches loose. All they need to do is stop the layers from sliding about too much.

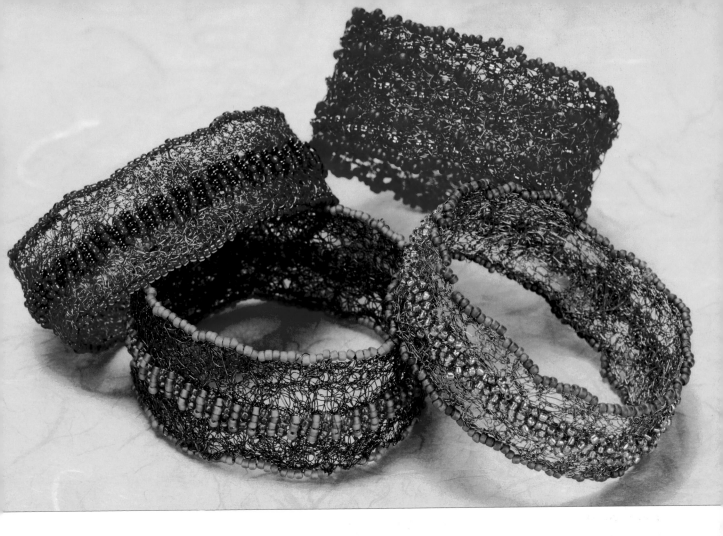

Adding beads *Finished diameter approximately 20cm (7¾in)*

Now your bangle is ready for beading. The samples above are decorated with seed beads, but all sorts of goodies apply here: crystal chips, bigger beads, sequins or shells. Attach a length of beading or sewing thread to the edge of your bangle and thread on a beading needle. Pick up three seed beads and oversew the edge, as you did for the brooch edge on page 25.

To add the row of beads along the centre of the bangle, attach the thread at the back, bring it through to the front and pick up four beads. Make sure the stitch is the same length as the beads and pass through to the back. Line up your beads in stitches side by side, as shown on the bangles above. You can alternate bead colours to add more detail.

If you find stitching a neat row too fiddly there are options. Stagger the stitches so they are not so neatly lined up, as on the turquoise bangle. Alternatively, stitch a running stitch along the length of the bangle, bring the needle out to the front, add beads, pass to the back, then bring the needle to the front to add more beads, as on the red bangle. If you want an even more robust bangle like the green one, right, work the rectangle in 0.315mm wire and add chunkier beads.

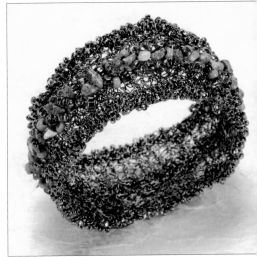

Talismans

now try adding some padding

The final technique to explore with folding and layering is padding. By stuffing your layers you can create three dimensional pendants, keyrings, amulets and talismans. If you are into secret wishes, add a poem, a prayer, a good luck wish or object within the padding. Folded and layered knitting is not entirely opaque, so select a padding material that is coloured to match or contrast with your wire colour.

Felt is great, but wadding, or coloured plastic works just as well. Source some thin plastic soft enough to be crushed. Perhaps it is time to recycle a carrier bag!

MATERIALS

5g (¼oz) size 11 seed beads in 2 colours

3.75mm knitting needles

0.200mm wire: 2 colours per talisman

1 jump ring

4 x 4cm (1½ x 1½in) felt or 1 coloured carrier bag

Tapestry needle (size 26)

Beading needle (size 10)

Beading or sewing thread to match wire colour

START KNITTING HERE

Main section

Use one strand of wire and cast on twenty stitches.

Row 1: Knit.
Row 2: Knit.
Repeat rows 1 and 2 until you have worked 40 rows.
Row 41: Cast off.
Repeat rows 1–41. You will now have two pieces for the main section.

Embellishment

Use one strand of wire in a different colour and cast on twenty stitches.
Knit until you have worked twenty rows.
Row 21: Cast off.

Forming the talisman

Smooth out a larger knitted rectangle, making sure the edges are straight.

For the main section, fold the rectangle lengthwise into three layers.
Fold this long narrow piece in half, making sure all the edges line up neatly.
Oversew the edges to capture the layers.
Now make small stitches from front to back, and back again, stitching all the layers together. Use random stitches all over the surface of your work. Repeat with the other large rectangle.

Repeat with the smaller section, but fold this one more time so that it forms a square, then oversew and stitch the layers together. You are now ready to construct your talisman.

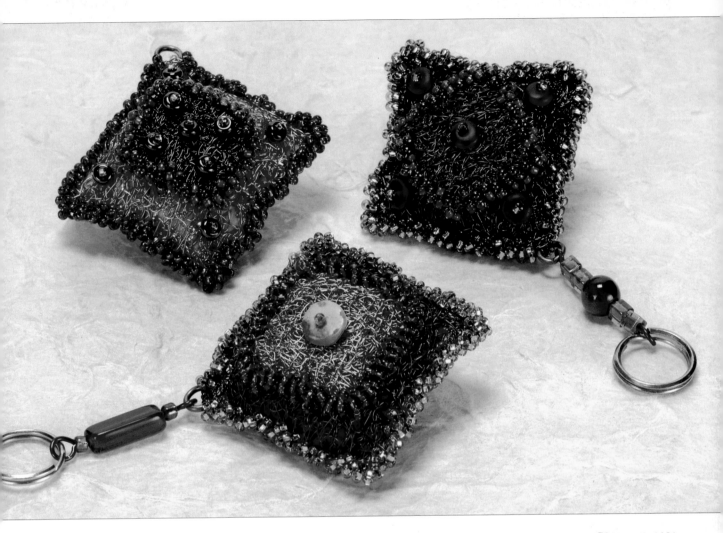

Making the talisman *Finished size approximately 4 x 4cm (1½ x 1½in)*

Take one of the larger squares and the smaller square. Sew the smaller piece to the centre of the larger square with sewing thread (see diagram A), then oversew the edges with beaded stitches to hide the joins (see page 25).

Take the two larger squares, with the embellishment on the outside, and oversew the edges together on three sides with wire. As you reach a corner, insert a jump ring and stitch it into place, making sure it is securely stitched (see diagram B). Stuff the talisman firmly, using felt, a recycled carrier bag or wadding, then oversew the final edge to close the talisman (see diagram C).

You can now add surface decoration with beads, to add more colour and texture. To finish off your talisman, oversew the edges and cover them with beaded stitches.

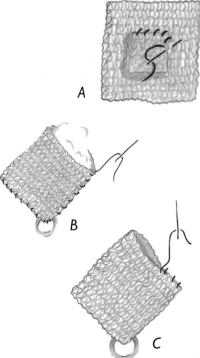

A

B

C

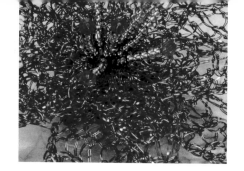

Star Flowers

knit yourself a bower full of flowers

Knitted wire is the ideal fabric for three-dimensional knitting. Flowers can be used to make luscious brooches, hairslides, corsages, hat decorations, bag accessories or even a bouquet just for display. In this section you can explore different flower shapes, all based on the simplest knitting patterns. Star flowers start as two strips of knitting with a spiky edge. Gather the straight edges, stitch them together and finish them off with a colourful flourish of beaded stamens. This design uses two strands of wire and one strand of thread together. Make sure as you knit that the thread is pulled up neatly.

MATERIALS

5g (¼oz) size 9 seed beads: purple

9 x 4mm crystals: yellow

3.75mm knitting needles

0.200mm wire : vivid red

Madeira rayon: red

Mesh fronted brooch back

Tapestry needle (size 26)

Beading needle (size 10)

Beading or sewing thread to match wire colour

Round-nosed pliers

START KNITTING HERE

With two strands of wire and one of thread cast on four stitches.

Row 1: Sl1, k1, sl1, inc1 (5).
Row 2: Knit.
Row 3: Sl1, k1, sl1, k1, inc2 (7).
Row 4: Knit.
Row 5: Sl1, k1, sl1, k3, inc2 (9).
Row 6: Knit.
Row 7: Sl1, k1, sl1, k4, inc 2 (11).
Row 8: Knit.
Row 9: Sl1, k1, sl1, knit to end.
Row 10: Cast off 7 stitches, knit to end (4).

Repeat rows 1–10, six times.
Row 61: Cast off.
Make a second section the same as the first.

Smooth out both knitted pieces, making sure the edges are straight, and that the tips of the points are nice and pointed. Finish off all wire and thread tails.

To make-up the flowers
Take a length of sewing thread and sew a line of running stitch along the straight edge of one of the knitted pieces (see diagram A opposite). Pull the knitting up so that it gathers into a circle. Keep the thread tight and knot the end to secure it. Sew the first and last petal edges together at the base.
Repeat with the second knitted piece.

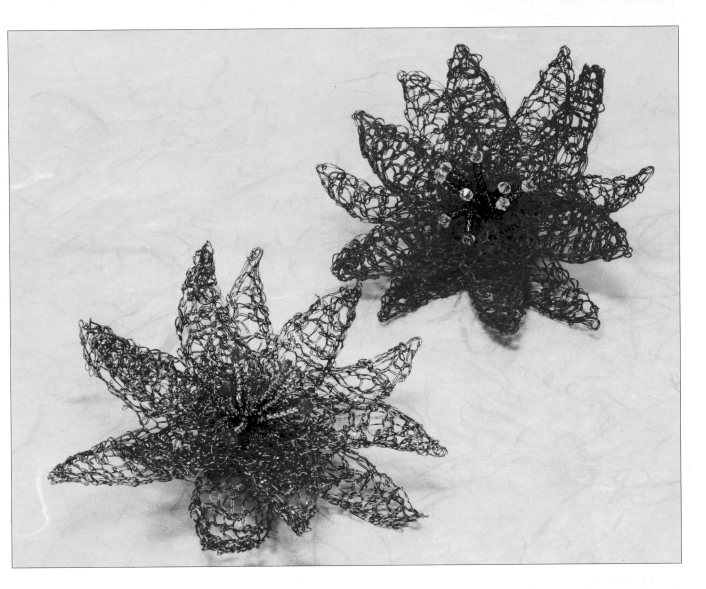

Making the flower brooch

When you have made a flower, remove the mesh section from the brooch back. Position the centre of the flower over the centre of the mesh. (There should be a small central hole in the flower, as the gathered edge does not close up entirely). Stitch the flower in place by stitching through the centre edge of the flower and the mesh, then back again, with sewing thread.

To make the stamens, secure a single length of wire to the mesh and bring it out through one of the holes in the centre. Thread on nine size 9 beads and one crystal. Thread the wire end back through all the size 9 beads and the hole in the mesh, pulling it gently until the stamen stands up with the crystal on top. Repeat through the other holes in the mesh until you have made nine stamens (see diagram B). These should fill the centre area.

Finish off the wire at the back by twisting the two tails together.
Fit the mesh back into the base of the brooch back and fold the little metal tags over with your round-nosed pliers to hold the grill in place.

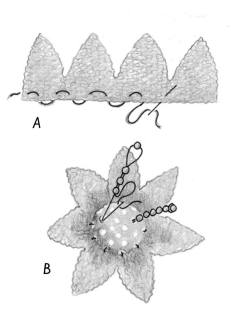

A

B

31

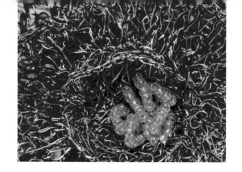

Spring Flowers

coil and twist your knitting into a cute camelia

There are many ways to manipulate knitting so that it makes pretty petal shapes. This one is so simple. It starts with a few rows of knitting, then holding the right hand needle steady, the left hand needle, with stitches, is rotated one full turn. This twists the knitting between the stitches. Used with yarn, this technique makes a soft dome shape; with wire it becomes a wonderfully rounded petal edging. The rest of the flower is simple decreasing. If a second piece is coiled and stitched to the first your knitting becomes a dainty spring flower, which looks a bit like a Camelia.

MATERIALS

5g (¼oz) size 11 seed beads: green

3.75mm knitting needles

0.200mm wire: silver, pink

Tapestry needle (size 26)

Beading needle (size 10)

Beading or sewing thread to match wire colour

START KNITTING HERE

With two strands of wire cast on 72 stitches.

Base section
Row 1: Knit.
Row 2: Purl.
Row 3: Knit.
Row 4: Purl.
Row 5: K8, twist (see above), repeat to end*.
Row 6: Purl.
Row 7: K1, k2tog, repeat to end (48).
Row 8: Purl.
Row 9: K2tog, k1, repeat to end (32).
Row 10: Purl.
Row 11: K2tog, k1 repeat to end (22).
Row 12: Purl.
Row 13: K2tog, k1, repeat to end (15).
Row 14: Purl.
Row 15: Cast off.

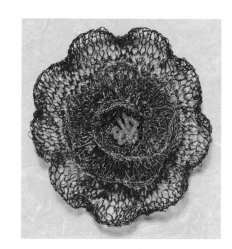

Centre section
knit as for base section to *
Row 6: P2tog, repeat to end (36).
Row 7: K2tog, repeat to end (18).
Row 8: P2tog, repeat to end (9).
Row 9: Cast off.

You can use this method to make other flower shapes by working strips with more, or less petals and sewing them on top of each other.

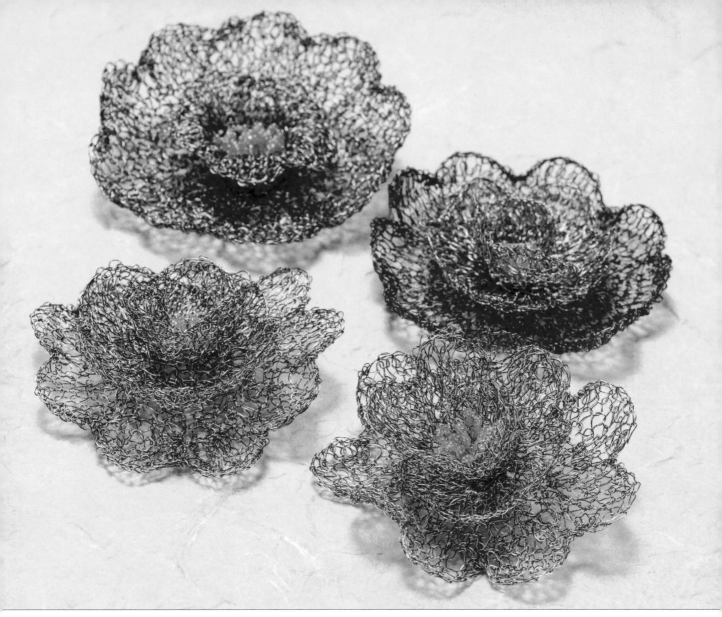

Making the flowers

Take the base section and make a running stitch along the cast off edge. Pull up the thread to gather the knitting until it forms a circle (see diagram A). Fasten off the thread to hold the knitting in place. Stitch the sides of the first and last petal together with one strand of wire.

Take the centre section and, stitching only on the cast off edge, coil one end round and stitch it to the base of the fourth petal from that end.
Bring the other end round and stitch it to the base of the same petal (see diagram B).
Stitch along the cast off edge, drawing it in to close the centre.
Position the coiled section over the base section and stitch the centres together.
To add the stamens, bring a length of wire through to the centre of the coil, thread on eleven size 11 seed beads, then pass the wire to the back of the flower. Repeat until the centre of the coil is filled with loops of beads.

A

B

Rosebuds

no knitted garden is complete without a rose

The easiest flower to knit and make is the rosebud. One pattern makes all these rosebuds; the size is determined by the size of knitting needles and the number of strands of wire and thread used. Instructions are given for the little rosebud hairslides. To make the medium rose change to 3mm needles, one strand of wire and one strand of blending filament. To make the larger rose use 3.75mm needles, two strands of wire and add in an optional strand of blending thread for added sparkle. The rose itself is a simple strip, folded and stitched into place. The leaves are easy: increase and decrease with the edges wrapped in wire for a firm outline.

MATERIALS

2.75mm knitting needles

0.200mm wire: vivid red, vivid green

Brooch pin

Tapestry needle (size 26)

Sewing thread

START KNITTING HERE

Rosebud
With one strand of wire cast on 20 stitches.

Row 1: Sl1, k18, sl1.
Row 2: Purl.
Repeat rows 1 and 2 until you have worked 36 rows.
Row 37: K2tog, k16, k2tog (18).
Row 38: Purl.
k2tog at start and end of every knit row until you have 10 stitches remaining.
Row 47: Cast off.

Leaf
Make two
With one strand of wire cast on three stitches.
Row 1: Knit.
Row 2: And all even numbered rows, purl.
Row 3: Inc1, k1, inc1 (5).
Row 5: Sl1, inc1, k1, inc1, sl1 (7).
Row 7: Sl1, k1, inc1, k1, inc1, k1, sl1 (9).
Row 9: Sl1, k2, inc1, k1, inc1, k2, sl1 (11).
Row 11: Sl1, k9, sl1.
Row 13: Sl1, k2, k2tog, k1, k2tog, k2, sl1 (9).
Row 15: Sl1, k1, k2tog, k1, k2tog, k1, sl1 (7).
Row 17: Sl1, k2tog, k1, k2tog, sl1 (5).
Row 19: Sl1, k2tog, k2tog (3).
Row 20: Cast off leaving a 20cm (7¾in) wire tail.

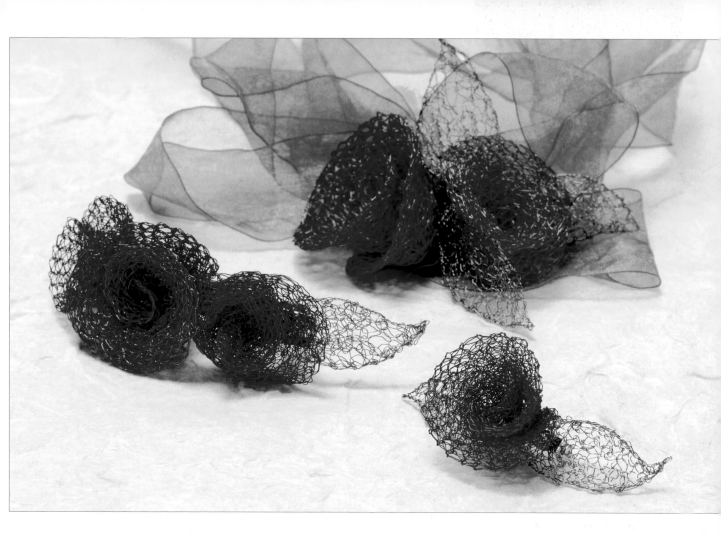

A

B

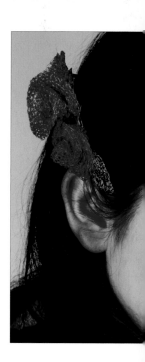

Making the rosebud and leaf

Smooth out your knitted pieces. Take the rosebud section and fold it in half along its length. Use a running stitch of sewing thread through both raw edges (cast on and cast off edges) together and gather up the knitting (see diagram A). Cast off the thread to hold the coil in place.

Roll the coil so that the narrow end is in the centre, and stitch the gathered edges together at the base of the roll (see diagram B).

Stitch the short edge to the base to make the knitting curve round to the base. Gently press and stretch the folded edge into shape.

To finish off the leaf, thread the long tail of wire on to a tapestry needle and oversew the edges, just as you did for the Droplet Lariat on page 19.

Sew the rosebud to the centre of a brooch pin with thread or wire.

Sew one leaf to either side of the rosebud, making sure that it covers the end of the brooch pin, then pull the leaves into shape.

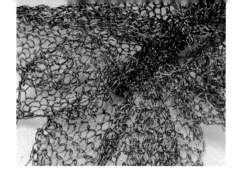

Leafy Leaves

knit yourself some fabulous foliage

This variation of a single leaf is even easier to knit than the rosebud leaf. Work with two strands of wire and experiment with your colours. You can blend two close shades, or use contrasting shades to give you a whole autumn full of leaf variations.

MATERIALS

3mm knitting needles

0.200mm wire: 2 strands

Tapestry needle (size 26)

START KNITTING HERE

Single Leaf

With two strands of wire cast on two stitches.

Row 1: Purl.
Row 2: Inc1, inc1 (4).
Row 3: Purl.
Row 4: Inc1, k2, inc1 (6).
Row 5: Purl.
Row 6: Inc1, k4, inc1 (8).
Row 7: Purl.
Row 8: Knit.
Row 9: Purl.
Row 10: K2tog, k4, k2tog (6).
Row 11: Purl.
Row 12: K2tog, k2, k2tog (4).
Row 13: Purl.
Row 14: K2tog, k2tog (2).
Row 15: Purl.
Row 16: Cast off, leaving a 20cm (7¾in) tail.

Autumn leaf colour combinations

Gold, silver

Gold, gunmetal

Gold, mid brown

Gold, vivid red

Silver, vivid green

Gunmetal, vivid green

Vivid green, leaf green

Vivid red, mid brown

There are lots more combinations to play with, so you are sure to be able to 'mix' the right colour for your corsage or hat.

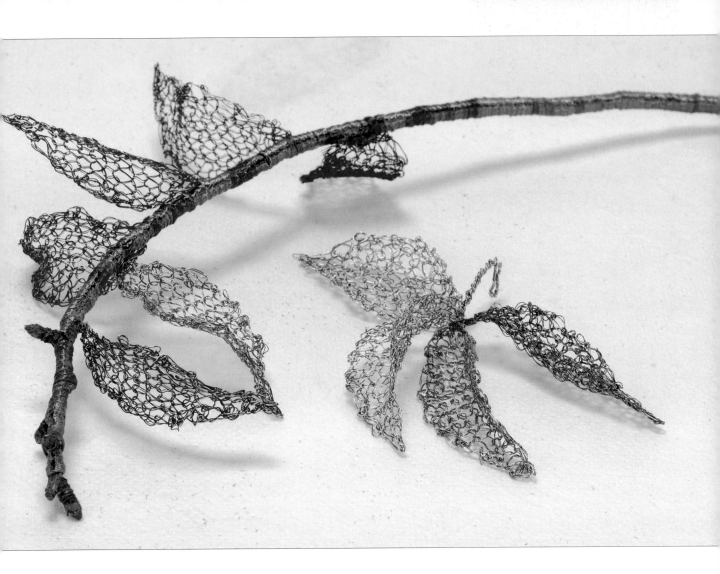

Making the leaves

Smooth out your knitted pieces.

If you want to you can add more definition to your leaves by oversewing the edges with one or both of the wire colours you have used.

The long tail makes it easy to bind leaves to the base of flowers, or to each other to make a trail of leaves.

Add leaves to a bag front for some added autumn colour or stitch several to a brooch pin or hairslide.

If you like flower arranging, take a small branch and bind your leaves to it with the wire tails, then wrap the branch with bark coloured thread or florist's tape.

For an autumn hairslide, wrap a slide base in sparkly yarn then twist the leaf wires into place. Add a few leaves to a small hairslide, more to a bigger one.

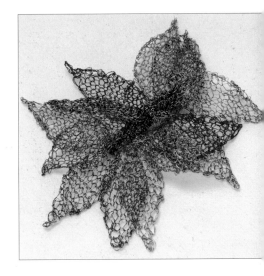

Pointy Leaves

leaves come in all sorts of shapes and sizes

You only have to step into a garden to see just how infinite is the variety of leaf shapes on offer. The wintery three-pointed leaf hints at ivy and is simple to knit. The increasing takes place along the centre vein of the leaf, angling the stitches. The decreasing (shaping), is a simple case of casting off part way through your knitting. To make smaller leaves, all you have to do is reduce the number of strands of wire and thread used and drop down the size of your knitting needles to form smaller stitches.

MATERIALS

3mm knitting needles

0.200mm wire: leaf green,

Thread: Coats reflecta colour 0313 or similar

Tapestry needle (size 26)

START KNITTING HERE

With one strand of wire and one strand of thread cast on five stitches.

Row 1: Purl.
Row 2: K1, inc1, k1, inc1, k1 (7).
Row 3: Sl1, p5, sl1.
Row 4: K2, inc1, k1, inc1, k2 (9).
Row 5: Sl1, p7, sl1.
Row 6: K3, inc1, k1, inc1, k3 (11).
Row 7: Sl1, p9, sl1.
Row 8: K4, inc1, k1, inc1, k4 (13).
Row 9: Sl1, p11, sl1.
Row 10: K5, inc1, k1, inc1, k5 (15).
Row 11: Sl1, p13, sl1.
Row 12: K6, inc1, k1, inc1, k6 (17).
Row 13: Sl1, p15, sl1.
Row 14: K7, inc1, k1, inc1, k7 (19).
Row 15: Sl1, p17, sl1.
Row 16: Cast off 6, knit to end (13).
Row 17: Cast off 6, purl to end (7).
Row 18: Knit.
Row 19: Sl1, p5, sl1 (7).
Repeat rows 18 and 19, two more times.
Row 24: K1, k2tog, k1, k2tog, k1 (5).
Row 25: Sl1, p3, sl1.
Row 26: K2tog, k1, k2tog (3).
Row 27: Purl.
Row 28: Cast off.

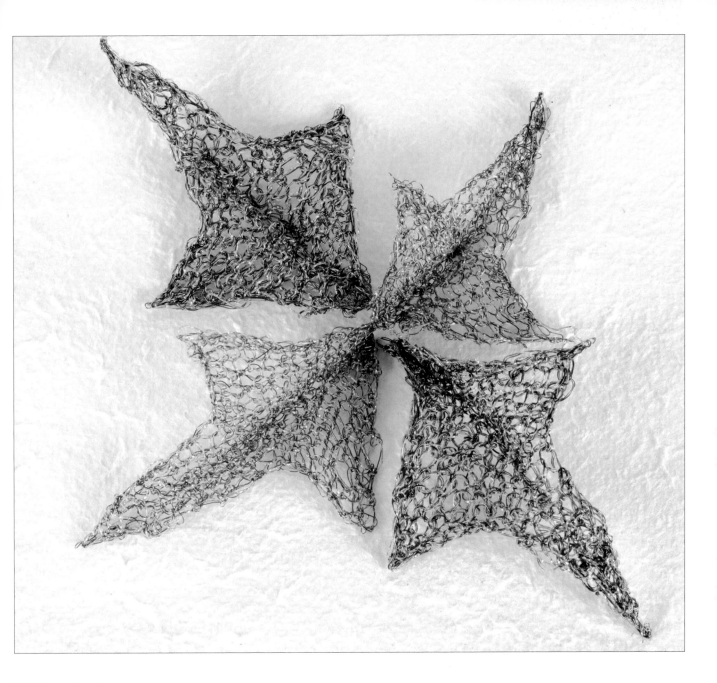

Making the leaves

Smooth out your knitted pieces.

Fold the leaf along the centre line and gently open it out again so that the crease stays in place.

For added sparkle you can bind the edges, and stitch a central vein using a blending thread. For winter frosting use several strands of silver metallic thread.

These larger leaves work well in a posy of knitted flowers. To make a bigger display bind several leaves to a length of florists' wire, then bind the wires with a sparkly thread.

For a more substantial leaf, use a heavier thread with your wire, it will gently fill in the spaces of the stitches. Try using a silk thread for a soft leafy sheen. If you need bigger leaves use larger knitting needles and more strands to knit with.

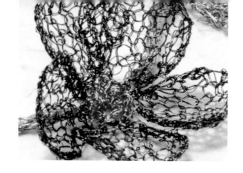

Petal Flowers

loves me, loves me not, one petal at a time

These flowers have separate petals, with each petal worked individually but kept on the needle. The petals are then joined with three rows of knitting in a different colour. You may find it easier to stretch out each completed petal and to bind the edges with the wire tail before starting to knit the next petal. The garland is worked as a tube of French knitting; the leaves and flowers are then attached with wire tails.

MATERIALS

2.75mm knitting needles (flowers)

3mm knitting needles (leaves)

0.200mm wire: silver, supa blue (light flower), supa blue, dark purple (dark flower), gold, silver (light flower centre), 2 strands gold (dark flower centre), silver, leaf green, (leaves, cord)

Thread: Coats reflecta colour 0313 or similar (leaves, cord)

Tapestry needle (size 26)

4-pin French knitting dolly

START KNITTING HERE

With two strands of wire cast on five stitches.

Rows 1, 3 and 5: Purl.
Row 2: Inc1, k3, inc1 (7).
Row 4: Inc1, k5, inc1 (9).
Row 6: Knit.
Row 7: K2tog, k5, k2tog (7).
Row 8: P2tog, p3, p2tog (5).
Row 9: K2tog, k1, k2tog (3).
Cut off the wire leaving a 20cm (7¾in) tail. Leave the last three stitches on the needle.

Keep worked petals on the left needle. Work five petals in total. Change to gold wire.
Row 10: Purl across all the petals to join them together (15).
Row 11: K2tog, repeat to last stitch, k1 (9).
Row 12: Purl.
Row 13: Cast off.

Leaves
With two strands of wire and one strand of thread, cast on eleven stitches.
Row 1: Knit.
Row 2: K2tog, k9 (10).
Row 3: K7, k2tog (8).
Row 4: Cast off.
Leave a tail and twist the wire ends together at the base of the leaf.

Garland
With two strands of wire and one strand of thread, make a 65cm (25½in) length of French knitting (see page 42). Stretch and smooth the tube.
Finish off the thread and wire tails.

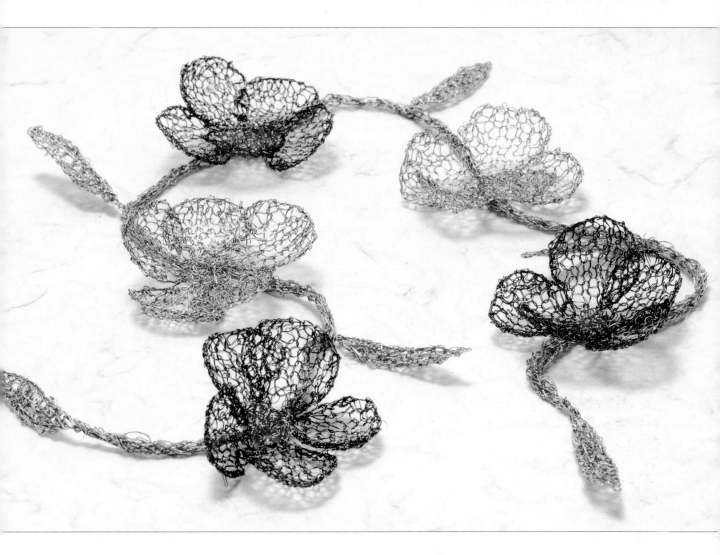

Making the garland

To make the 65cm (25½in) garland you will need to knit five flowers and six leaves. To finish the flowers, bring the cast off edge together in the centre and oversew it with gold wire. Keep stitching until you are happy with the flower shape (see diagram A).

Joining it all together

Use the existing wire tails and attach one leaf to each end of the French knitting (see diagram B). Evenly space the remaining four leaves along the French knitting, approximately 12cm (4¾in) apart. (Attach the leaves with the wire tails by stitching into the French knitting.

Attach one flower in each space between the leaves.

To make a longer garland just multiply the length of French knitting and the number of leaves and flowers needed. Worked in shades of pink the flowers become spring blossom. Use yellows for buttercups or purples for primulas.

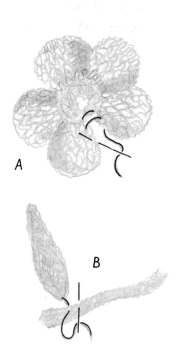

A

B

Secret Pearls

knit a tube and cram it full of treasures

We have tried flat, folded and shaped wire knitting, so now let us explore tubular knitting. French knitting is a great technique for creating simple tubular forms with wire. All you need is a standard four-pin knitting dolly. Most knitting stores carry them, or you may find them in children's craft sections at toy stores. First let us exploit the hollow nature of French knitting, because if wire is used, it becomes a delicate mesh. The mesh is hollow and unless you use really thick wire (which is exhausting work), the mesh can crush into a skinny tube, never to be rescued! One answer is to fill it with something gleaming and gorgeous. If pearls are not your favourite, use round glass or faceted crystal beads instead.

MATERIALS

5mm pearl beads (32)

4-pin French knitting dolly

0.200mm wire: gunmetal, black, or gunmetal, silver, or 2 strands gunmetal

Crochet hook or tapestry needle

Round pencil or pen

2 end caps with clasp

Strong glue

Beading thread

Beading needle (size 10)

START KNITTING HERE

Using a knitting dolly

Use two strands of wire and pass the tails of the wire down through the hole in the centre of the dolly. Allow yourself enough tail to hold as you prepare and work the first stitches.

Wrap both wires once around each of the pins at the top of the dolly, positioning them so they cross behind the pin.

When you are back at the first pin again, pass the wires in front of it above the loop of wires already there.

Use a crochet hook or tapestry needle to hook under the loop.

Lift the first loop over the wires passing in front of the pin, and off the pin.

The wires that were passing in front have now taken the place of the loop.

Do the same on each pin. Then just keep working around.

Your knitted tube will begin to gather over the hole so gently pull the wire tails to draw it through the hole in the dolly.

Do not pull too hard as this will stretch the loops on the pins, making it harder to lift them off next time around. It will also make them bigger, which will stretch your knitted tube too much. A good rule of thumb is to have about three stitches above the hole.

Make a tube 18cm (7in) long. Remember to include the knitting inside the dolly when you measure your work.

To cast off, cut a wire tail and make the next stitch, pull the tail right through the stitch. Repeat with the other three stitches..

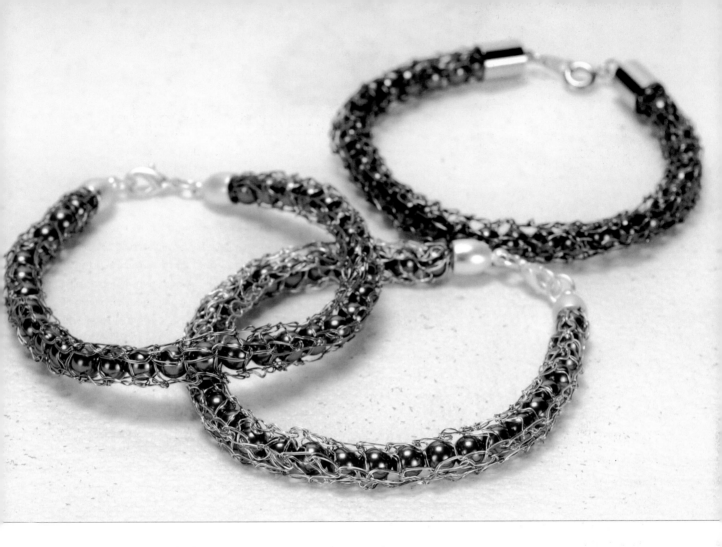

Making the bracelet *Finished length including clasp 19.5cm (7⅝in)*

To open out the tube, pass a round pencil or pen through the centre and then roll it gently against a flat surface.

Thread your pearl beads on to a length of thread. Leave a 20cm (7¾in) tail. Thread the needle and thread with the beads on, down through the centre of the knitted tube (see diagram A). You may have to ease out the ends so that the beads pass through.

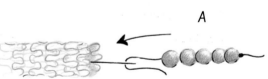

A

When all the beads are inside the tube, use the wire tails to twist round and close off the tube ends, over the first and last bead. Pull the thread tight and knot off the ends. Snip off any thread and wire tails.

End caps are little metal caps into which you can glue necklace and bracelet ends which need a neat finish. Use a glue recommended for sticking metal and other materials (see page 47). Glue each end of the bracelet into an end cap (see diagram B).

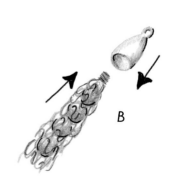

B

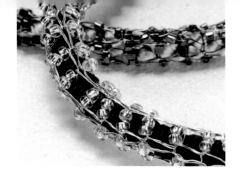

Beaded Braid

create a classic over slinky cord

French knitting can have beads on too! Now you know how easy it is to knit with wire on a knitting dolly, add in some beads to give your knitted tube more texture. Beads are threaded on to one wire, then pushed up to sit between the stitches, just as for regular knitting. The beaded braid is worked over a length of satin cord which results in a soft and flexible braid. It has a strong underlying colour as the cord completely fills the knitted tube. It is much easier to work round the cord than it is to try and feed the cord through afterwards. Getting it all started is a bit fiddly but it is well worth a few minutes of preparation time.

MATERIALS

15grams (½oz) size 9 seed beads (580 beads)

4-pin French knitting dolly

0.200mm wire: gunmetal, silver

50cm x 7mm (19¾ x ¼in) diameter satin cord

2 end caps with clasp

Strong glue

START KNITTING HERE

Thread all your beads on to one of the wires.
Use two strands of wire and work three rounds without beads (see page 42).
Check that you catch both strands as you lift the loops over the pins.
Pull the tail to draw in the end of the tube.

Wrap one end of your satin cord with sticky tape. Take a 40cm (15¾in) length of wire and fold it in half, then push it through the cord above the tape.

Fold the wire over the tape so that it sticks out beyond the end of the cord.

Pass the wire ends down through the knitting dolly, making sure that they pass either side of your first few stitches, (this ensures that the cord and knitting travel through the dolly together as you work). Pull your original wire tails and these new wire tails and twist them together. These help to anchor the end of the cord and enable you to feed it through the dolly easily as you work.

To add beads, slide up two beads until they are next to the pin of the last stitch worked, work the next stitch, then slide up two more beads.
Keep working round with two beads between each stitch.

You may find that you have to ease the first few stitches with beads on through the hole, but after that they should slide through quite comfortably along with the cord they are being worked around.

Keep working until your knitted tube measures 40cm (15¾in), or longer if you need a longer necklace, then fasten off your knitting and take it off the dolly.

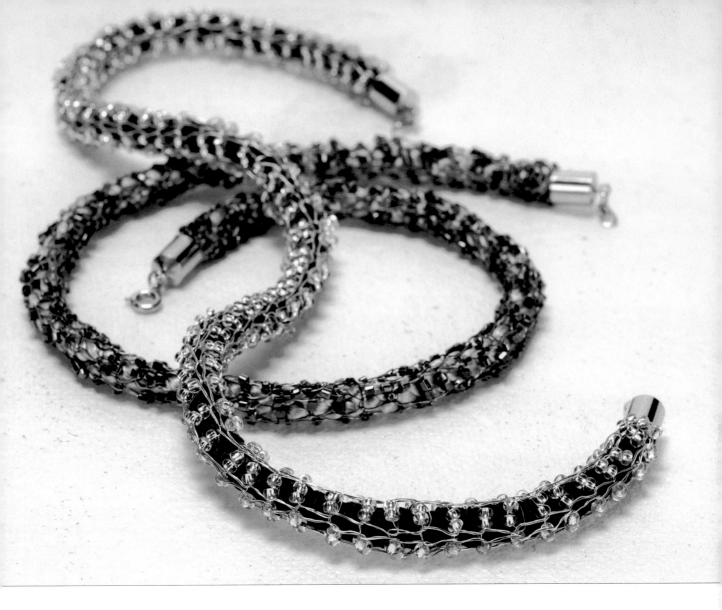

Making the necklace *Finished length including clasp 42cm (16½in)*

Remove the wires you used to secure the cord end.

Smooth your knitted tube along the cord until you have cord without tape on it protruding from each end. If any of the beads have moved out of position, take a little time to ease them back under the stitches with a pin, then pinch the wire to hold them in place.

Use the wire tails to wrap the cord at the end of your knitted tube. Wrap it firmly, then snip off any excess cord. It is useful to check at this stage that you have the right size end cap to fit the wrapped cord comfortably (see diagram).

Use a glue recommended for securing metal and follow the manufacturer's instructions (see page 47). Glue each end of the necklace into an end cap.

Smaller seed beads work just as well. Look out for faceted ones that will sparkle as your necklace moves.

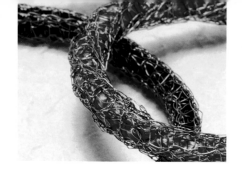

Layered Braid

keep them guessing with coloured layers

The method of feeding a core of cord through your dolly while knitting around it has lots of possibilities. Layered braid uses one strand of wire at a time to knit round the cord. The whole process can be repeated up to eight times, adding layers of colour. Each layer slightly overlays the last one, creating a regular pattern of colour changes. As if by magic the stitches will always contrive to sit above each other without your help. Once several layers have been added the tube takes on the appearance of a twisted square cord, just like the square wire mentioned in the history of wire on page 5.

MATERIALS

4-pin French knitting dolly

0.200mm wire: bright violet, supa green

70cm x 7mm (27½ x ¼in) diameter satin cord

2 x end caps with clasp

Strong glue

START KNITTING HERE

Use one strand of wire and work three rounds on the knitting dolly (see page 42). Pull the tail to draw in the tube end.

Prepare the end of your cord (see page 44) and thread it through your dolly, then keep knitting with the wire and feed the cord through as you work.
Knit until your work measures 60cm (23½in).

Cast off the wire in the usual way and remove your work from the dolly.
Wrap the cast off wire tail firmly round the cord.

Prepare the dolly with your next wire colour, and follow the instructions above.
Knit a new layer measuring 60cm (23½in).
Remove your work from the dolly, and holding the start end firmly, run your knitting through your hand to smooth out the second layer, and to make sure it starts and ends in the same place as the first layer.
Finish off the second layer by twisting the second cast of wire tail around the cord.

Start again with the first colour you used and repeat the whole process.
Then add one more layer with the second colour used.

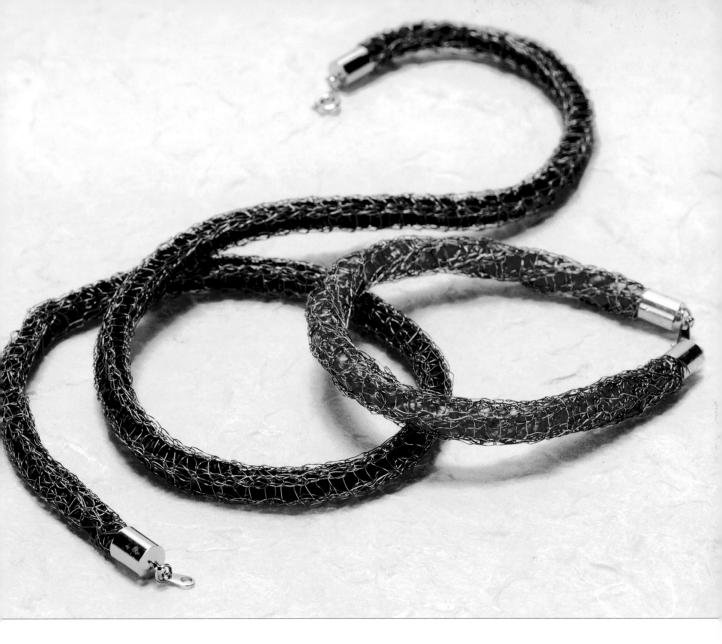

Making the necklace *Finished length including clasp 62cm (24½in)*

Remove the wires you used to secure the cord end and unwind the wire tails.
Smooth your knitted tube along the cord until you have cord without tape on it
protruding from each end.
Wrap the ends of your knitted tube to the cord with wire.
Trim off any excess cord.
Glue each end of the necklace into an end cap.

I use a fast-drying epoxy resin for most jewellery making that requires glue. It creates
a strong bond with just about any material and is water resistant. Epoxy resin does
contain irritants so always follow the manufacturer's instructions to the letter! There
are lots of alternative glues available, some of which are irritant free if you have sensitive
skin and feel unsure about what to use.

*The best sources for
glues and advice on
their uses are DIY or
craft stores*

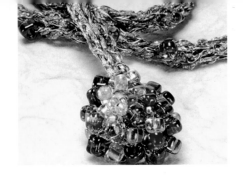

Rainbow Lariat

drape yourself with uncrushable braid

A long length of French knitting can be twisted, doubled, draped and tied. To avoid the tube being crushed out of recognition, all you need to do is add some body, in this case a slightly thicker decorative yarn. This yarn is a blend of metallic and synthetic thread. To allow the wire to compete happily with a more robust thread, just use three strands of wire. The beads are chunky triangles that sit at random round the outside of the tube, giving it a knobby texture. Using a thicker thread with your wire also makes the knitting process a little easier, as there is more bulk to see and handle as you work.

MATERIALS

20g (¾oz) 5mm triangles multicolour mix (85 beads)

4-pin French knitting dolly

0.200mm wire: bright violet, supa emerald, black

Thread: papillon starlight, black/rainbow or similar

START KNITTING HERE

Thread all your beads on to one strand of wire.

With three strands of wire (one beaded) and one strand of thread, cast on to your knitting dolly (see page 42).

Work several rounds, then slide up one bead.
Keep working, adding a bead occasionally.
Do not try to use more than one bead in any given round (if you do they are likely to get stuck and this will cause an obstruction in the dolly).
Cast off in the usual way.

Smooth out your knitting.
To make sure the beads sit on the outside of the knitting, take a pin and insert it into a bead, twist the bead once. This will twist the wire that the bead is threaded on to and hold the bead in place.

Finish off the thread and wire tails.

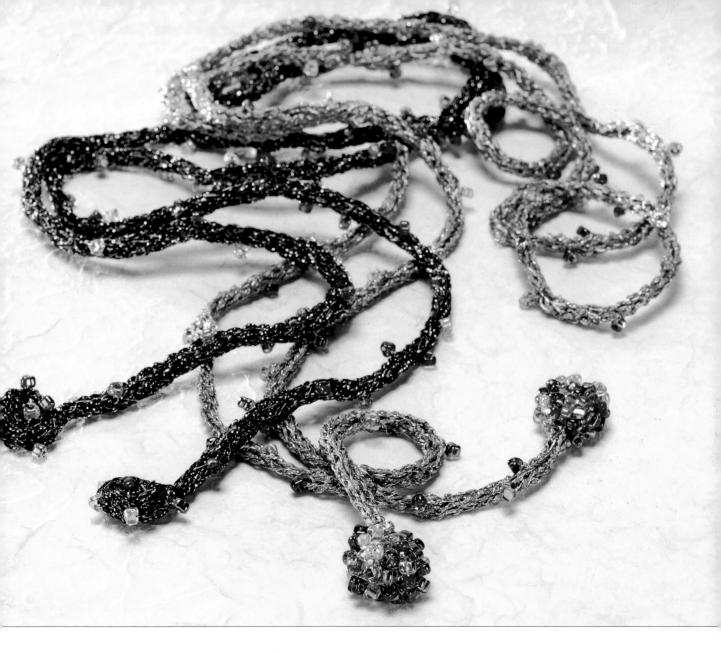

Making the lariat *Finished length 2m (78¾in)*

Take a length of thread and attach it to one end of your knitting.

Roll the first 6cm (2¼in) of your knitting into a flat coil and stitch it into place. Use small stitches to join the inside edge of the rope as you coil it up (see diagram).

If you are not a patient stitcher it may be easier to stitch right through the coiled section from one side to the other.

If you have more beads, add some detail and sew them all over the surface of the stitched coil, as shown on the silver lariat above.

The silver lariat uses silver instead of black wire, and silver rainbow yarn. There are lots of thicker threads available. Try experimenting with some of the fancy ribbon yarns that are now available. These come in a delicious colour range and have a silky rather than a sparkly finish. Choose matt textured beads to go with less sparkly yarns and your beaded lariat will be a subtle splash of colour, perfect for daywear.

Mi-Cord

i-cords are fun to knit in wire

I-cords are a form of knitting worked on double pointed-needles. They are used to make tubular knitting in yarn when you do not have a knitting dolly to hand.

An i-cord also enables you to knit more than four stitches into a tube.

Stitches are cast on and a row knitted, but instead of swapping needles over, the knitting is pushed to the other end of the needle. The yarn is passed behind the knitting, to be in place to knit the next row. By always knitting on the same face the work will look like stocking stitch without the need to work purl rows between the knit rows. Yarn is soft and flexible enough to stretch across the back of the stitches and pull the knitting into a tube, however wire is not.

The solution is to add beads as the wire passes behind the knitting to fill the space. Unlike all the other beaded knitting, for this technique you do need to thread the beads on to all the wires and threads you intend to knit with.

The result is a flat, yet flexible strip of knitting which has stocking stitch on one face, and neat rows of beads on the reverse, and it is ideal for gently curving collars. If you really need round i-cord you can thread a length of satin cord through your work once it is completed, as in the pink sample opposite.

MATERIALS

20g (¾oz) size 8 triangles (750 beads)

3mm double-pointed needles

0.200mm wire: supa violet, dark purple

Thread: Madeira glissengloss rainbow or similar

Box clasp

START KNITTING HERE

Use two strands of wire and one of thread, and thread all three with your beads. To make this an easy process, thread both wires and thread on to a needle that will pass through the bead hole.

Cast on seven stitches.
Row 1: Knit. Slide work to other end of needle, pass wire behind. (do this at the end of each row).
Rows 2–6: Knit.
Row 7 and all following rows: Knit. Add 5 beads to the wire as it passes behind.

Keep working until you have 148 rows of beads.
Knit 6 rows without beads.
Cast off.

Gently smooth your knitting, then finish off all the wire and thread tails.

Take one end section: flatten it, folding it over so all the loose wire and thread stitches are hidden and then stitch in place. Repeat on the other end.

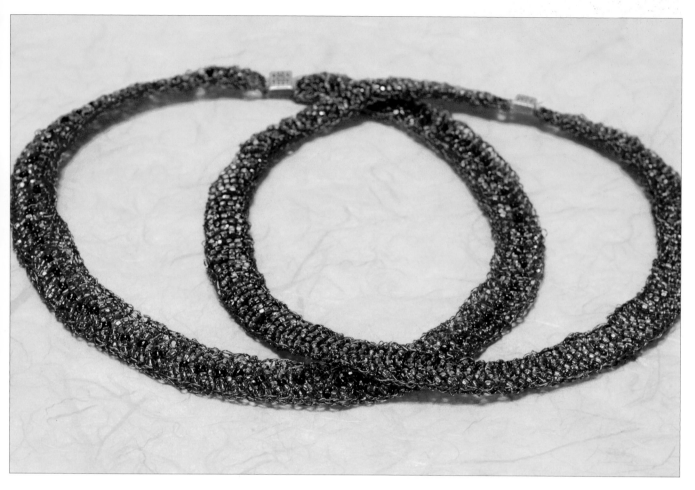

Making the necklace *Finished length including clasp 45cm (17¾in)*

Box clasps have two sections. One is like a little box and the other is a fold of metal which is sprung, so that it clicks into place.

With one strand of wire or thread, stitch the loops of the clasp sections to the ends of your necklace (see diagram).

Make several passes through each hole and finish off the wire tails.

Making the pink tube *Finished length 56cm (22in)*

Knit seven stitches with six beads over 190 rows (1140 beads).

Once knitted, take a length of 7mm (¼in) satin cord and thread it through the centre of your knitted tube.

Secure one end of the knitted tube to the cord and twist the knitting. Bind off the ends, then trim off any excess cord.

Glue the ends into end caps as shown on page 45.

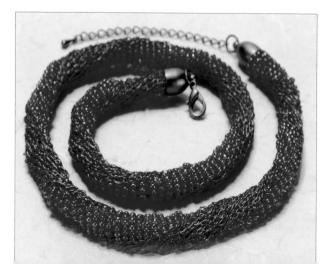

Wide Cord

mi-cord with an edge

I-cords worked with wire and beads make beautiful flat braids. If you add more stitches, but use the same number of beads, the finished i-cord will fold to create a knitted border either side of the beads. The wide cord bangles were knitted with nine stitches and five beads, resulting in a fine knitted edge to the beads.

The turquoise i-cord necklace uses droplets within the knitting, and even more stitches, creating a wider edging with detail.

MATERIALS

Necklace and bangle
3mm double pointed-needles
0.200mm wire: silver, supa green

Necklace
2 x 10g (³⁄₈ oz) size 9 pale and dark seed beads (2 x 375 beads)
20g (¾oz) Magatama droplet beads (75 beads)
Thread: DMC fil métallisé or similar
Box clasp or similar

Bangle
10g (³⁄₈ oz) size 9 seed beads gunmetal, mid brown, black (325 beads)

START KNITTING HERE

Necklace

Use two strands of wire and one of thread, put them on a needle and thread on your beads in the following sequence:

1 droplet, 5 pale, 5 dark seed beads; 1 droplet, 5 pale, 5 dark seed beads.
Repeat until you have 75 droplets, separated by 75 groups of 10 seed beads.
Cast on 9 stitches.

Row 1: Knit. Slide work to the other end of the needle, pass the wire behind. (Do this at the end of each row.)
Rows 2–6: Knit.
Row 7: K7, add droplet, knit to end of the row, add 5 beads to the wire as it passes behind.
Row 8: Knit, add 5 beads to wire as it passes behind

Repeat rows 7 and 8 until you have 148 rows of beads at the back of your work and 75 droplets on the front.
Knit 6 rows without droplets or beads, then cast off.
Gently smooth your knitting, flattening it so that the droplets sit along one folded edge, then finish off all the wire and thread tails.

Bracelet

Using 3 strands of wire, thread on 325 size 9 seed beads.
Cast on 9 stitches.
Rows 1–4: Knit.
Row 5: Knit 9, slide work to other end of needle, add 5 beads to wire as it passes behind.
Repeat row 5 until you have used all the beads.
Knit 4 more rows without beads, then cast off.

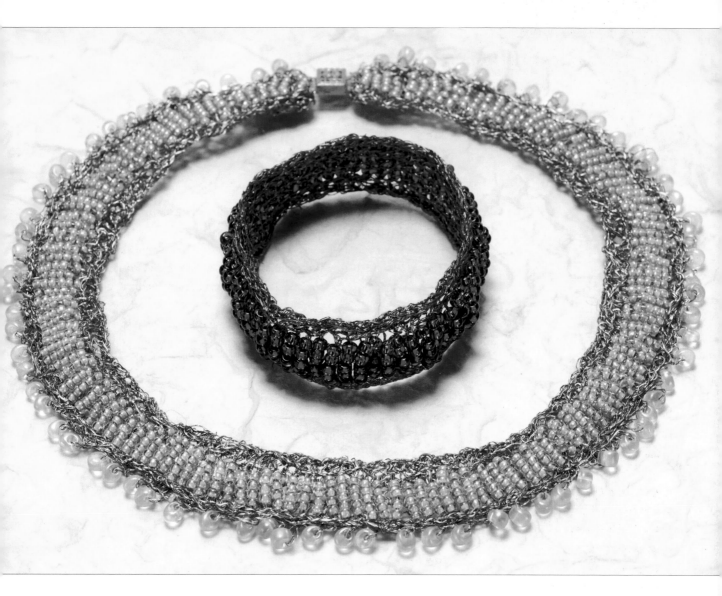

Making the necklace *Finished length including clasp 44cm (17¼in)*

Wide cords benefit from extra smoothing and stretching, so pull your work as
wide as it will go, then with one thumbnail at each end of the bead row, pinch the
wide cord flat. Work along the length of your knitting. This will help to position
the beads centrally on the front, allowing the knitted section to fold over.
To finish the necklace, attach the folded ends of your wide cord to the holes in the
box clasp (see page 51).
If you prefer you can fold the ends into a triangle and attach an alternative clasp,
such as a toggle clasp (see page 15).

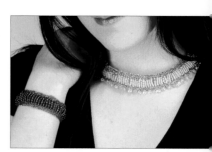

Making the bangle *Finished diameter approximately 9cm (3½in)*

Stretch and press your work as described above.
Bring the two knitted ends together, tucking one behind the other, and then
stitch them together.
Check on the front that the bead rows meet.
If you do find you have a gap, fill it by sewing in extra rows of five beads.

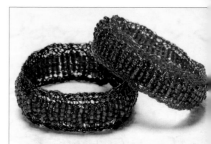

Fairy Collar

knit some enchanting layers

In this final section the delicate nature of knitted wire is used to create pretty layers and ruffles. The fairy collar is based on a simple strip of knitting with a beautiful spiky edge.

Worked with one strand of wire, each strip lays over the next to create a light and airy fairy collar. Colour plays an important part in adding to the subtle interplay of layers suitable for a magical necklace. Choose close-toned shades to build depth into your design. The second fairy collar is worked as one piece using the pattern below, but with two strands of wire it makes a firm base for a dusting of sparkly beads.

MATERIALS

3.75mm knitting needles

Seed beads

0.200mm wire: supa green, supa blue, dark blue

Snap fastener (press stud) small

START KNITTING HERE

Use one strand of wire and cast on six stitches.

Row 1: Sl1, k1, sl1, inc1, k1, inc1 (8).
Row 2: Knit.
Row 3: Sl1, k1, sl1, k2, inc1, k1, inc1 (10).
Row 4: Knit.
Row 5: Sl1, k1, sl1, k4, inc1, k1, inc1 (12).
Row 6: Knit.
Row 7: Sl1, k1, sl1, k6, inc1, k1, inc1 (14).
Row 8: Knit.
Row 9: Sl1, k1, sl1, knit to end.
Row10: Cast off 8 stitches, knit remaining 6.

Repeat rows 1–10, 16 times, (17 points on the pointy edge).
Cast off.
Make two more, one in each colour.

Smooth out your knitted pieces making sure all the edges are straight, and that the points are nice and pointed. Finish off all wire tails.

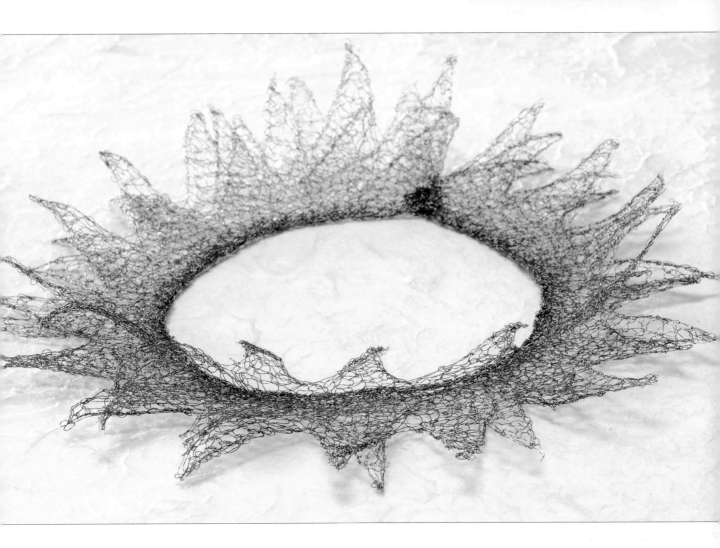

Making the collar *Finished length inside edge including clasp 43cm (17in)*

Lay all three layers on top of each other with the straight edges together.
Oversew the straight edge of all three layers, joining them together with wire.

With thread or wire sew the snap fastener to the inside corner of each end, one half
on the front at one end, the other half on the back at the
other end. Check that your necklace lines up neatly when the
snap fastener is closed.

To decorate your single layer collar with fairy dust, choose
size 11 seed beads and stitch them round the edges of the
points. Use several beads and oversew each stitch. You can
decorate the neck edge with more beads. Use straight stitches
filled with beads on the front surface only.

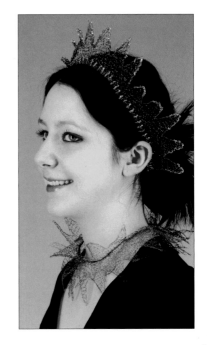

Fairy collars can also be stitched on to Alice bands for instant fairy tiaras. Choose a
narrow metal or plastic Alice band and cover your stitches with beads.

Lace Collar

a classic pattern for classy gatherings

Most lace, cable and other surface knitting patterns look indistinct when worked in wire. However, with the addition of a soft thread and more than one strand of wire, the most simple lace patterns can work. This knitted edging is commonly used for doilies and other home accessories, but with a little adjustment it becomes a cute collar destined to complement every party girl's little black dress.

MATERIALS

20g (¾oz) size 6 seed beads (60 beads)

2.75mm knitting needles

0.200mm wire: black, gunmetal

Thread: crochet cotton size 8: black

Tapestry needle (size 26)

2 jump rings

Clasp

START KNITTING HERE

Use two strands of wire and one of thread and cast on six stitches.

Row 1: K3, yo, k2tog, yo, k1 (7).
Row 2: Knit.
Row 3: K4, yo, k2tog, yo, k1 ((8).
Row 4: Knit.
Row 5: K5, yo, k2tog, yo, k1 (9)
Row 6: Knit.
Row 7: K6 yo, k2tog, yo, k1 (10).
Row 8: Knit.
Row 9: Cast off 4 stitches, knit remaining 6.

Repeat rows 1–9, 18 times (19 points on the pointed edge).
Cast off.

Sizing the collar
The finished collar size is 38cm (15in). If you need a slightly larger collar, knit one or more repeats of rows 1–9 and check the fit as you work.
Smooth out your knitted piece, making sure all the edges are straight, and all the points are nice and pointed.

Finish off all the wire and thread tails.

The silvery version of the collar was knitted in the same way using two strands of wire and one of a metallic sewing thread. Though it is slightly finer than the crochet cotton, the metallic thread still holds the lace pattern.

If you are not a sparkly bead person, just bind all the collar edges by oversewing them with the thread you have used to knit with.

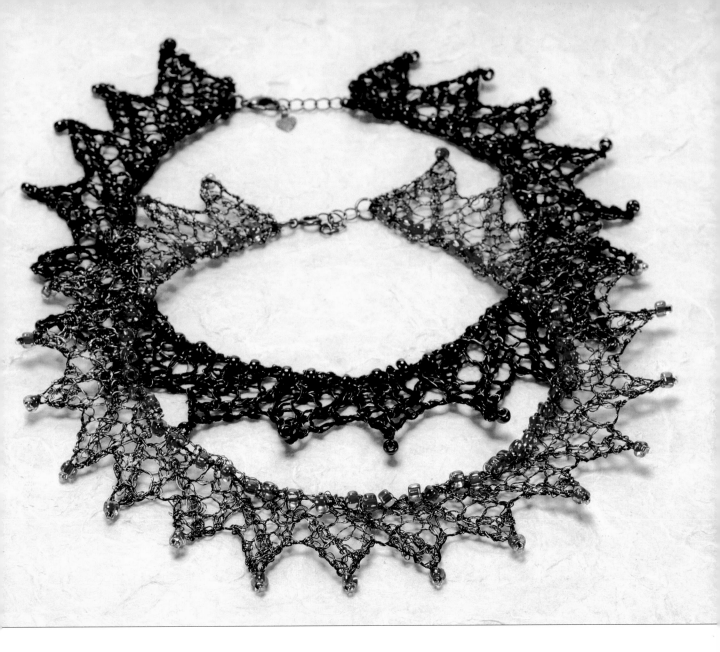

Making the collar *Finished length inside edge including clasp 38cm (15in)*

Thread a length of crochet cotton on to a tapestry needle and attach it to one end of
the straight edge of your knitting.

Oversew all the edges, working along the straight edge first. This helps to neaten edges
and hold your knitted piece in place with added support.

As you come to each point tip, add one size 6 seed bead. Thread on the bead, oversew
into the stitch at the top of the point, then sew the next stitch as usual (see diagram).

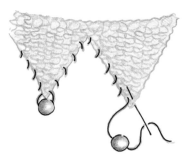

To add the beads at the neck edge, make a running stitch along the first line of knit
stitches and add a bead into every other stitch.

Attach a clasp to the jump rings inserted into the ends of the straight edge.

If the collar fit is just a little small, but adding an extra point makes it too large, use a
clasp that is supplied with a safety chain to extend the length of the collar slightly.

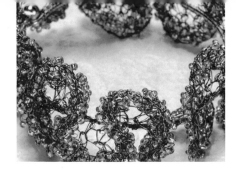

Ruffles

knit an armful of flouncy bangles

To create ruffles you need to knit more stitches on one side of your work than the other. The ruffle bangle and hairslide are worked the simple way, overleaf you can get to grips with a true spiral. The only shortcoming of the ruffle technique here is that you are limited by the number of stitches you can squeeze on to a needle. You can overcome this to make even longer sections by using a circular needle (two needle ends that are attached to a length of plastic tubing). The knitting starts with the greatest number of stitches and then decreases. Beads are included to add texture to the first two rows.

MATERIALS

3.75mm knitting needles

0.200mm wire: supa green

Tapestry needle (size 26)

Bangle

17g (½oz) size 9 seed beads (1008 beads)

Thin metal bangle

Hairslide

11g (⅜oz) size 9 seed beads (800 beads)

Hairslide base

START KNITTING HERE

Bangle

Thread all of your beads on to one of the wires.
Use two strands of wire and cast on 252 stitches.

Row 1: K1, add 2 beads, repeat to end.
Row 2: K1, add 2 beads, repeat to end.
Row 3: Sl1, k1, psso, repeat to end (126).
Row 4: Sl1, k1, psso, repeat to end (63).
Row 5: Cast off.

Hairslide

Thread all of your beads on to one of the wires.
Use two strands of wire and cast on 200 stitches.

Row 1: K1, add 2 beads, repeat to end.
Row 2: K1, add 2 beads, repeat to end.
Row 3: Sl1, k1, psso, repeat to end (100).
Row 4: Sl1, k1, psso, repeat to end (50).
Row 5: Cast off.

Smooth out your knitting until both edges are stretched to their fullest extent. The knitting will spiral spontaneously.

Finish off all the wire ends.

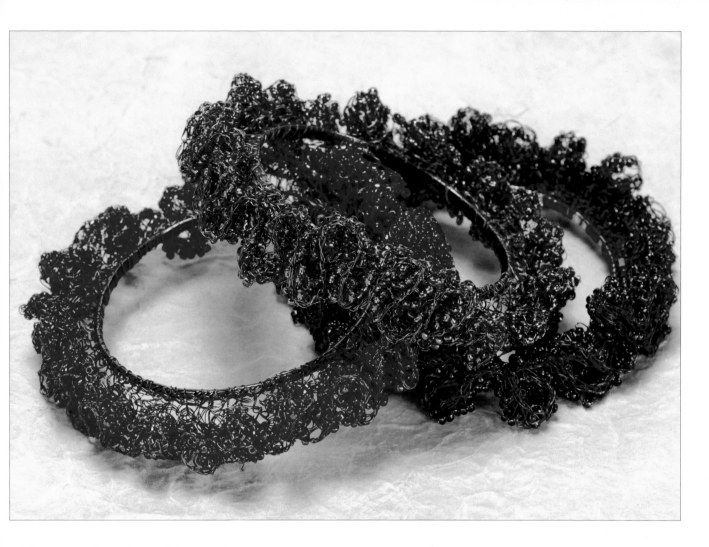

Making the bangle and hairslide

To make the bangle, attach a length of wire to one end of the cast off edge of your knitting. Oversew this edge to the metal bangle. Choose a wire colour to match the bangle colour. Metal bangles are available in most fashion jewellery stores and you can also find them in charity shops.

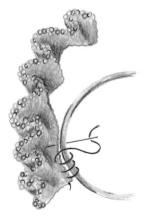

The knitting will be longer than the bangle circumference so you will need to slide your stitches along as you work. When you have attached the knitting, stitch together the short edges. Arrange the ruffles into even pleats.

To make the hairslide, attach a length of wire to one end of the cast off edge.
Arrange your stretched out ruffle so that it makes a nice shape which covers the hairslide base, then stitch it into place by oversewing the cast off edge to the base of the hairslide.

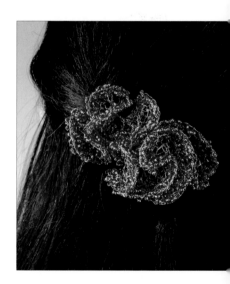

Spiral Scarf

knit yourself a show-stopping spiral scarf

Spiral knitting is not for the faint-hearted, but it is easier with this pattern. The long collar is worked in one piece, with a flattened section to sit behind your neck.
The spiral forms because you leave stitches on the needle when you turn the work.
The trickiest part is the backward yarn over (see Terminology on page 63).
The number of stitches you should have on each needle after you have turned your work around, and the number of stitches you should have at the end of each purl row, are both given so that you can check your progress.

MATERIALS

3mm knitting needles

0.20 mm wire : Mid Brown, Warm Gold

START KNITTING HERE

Cast on nine stitches using both strands of wire.

Row 1: Purl 6sts, sl1 p1,sl1.	(9)
Row 2: K1, yf, sl1, yb, k6, turn.	(8st on left needle, 1 on right)
Row 3: Byo, purl to last 3st, sl1, p1, sl1.	(10)
Row 4: K1, yf, sl1, yb, k5, turn.	(7st on left needle, 3 on right)
Row 5: Byo, purl to lst 3st, sl1, p1, sl1.	(11)
Row 6: K1, yf, sl1, yb, k4, turn.	(6st on left needle, 5 on right)
Row 7: Byo, purl to lst 3st, sl1, p1, sl1.	(12)
Row 8: K1, yf, sl1, yb, k3, turn.	(5st on left needle, 7 on right)
Row 9: Byo, purl to lst 3st, sl1, p1, sl1.	(13)
Row 10: K1, yf, sl1, yb, k2, turn.	(4st on left needle, 9 on right)
Row 11: Byo, purl to lst 3st, sl1, p1, sl1.	(14)
Row 12: K1, yf, sl1, yb, k2, then k2tog 5 times.	(9)

You should now have nine stitches on your needle.
Repeat rows 1–12 until your work is the desired length for your collar side, approximately 40cm (15¾in) along the inner edge when pulled straight.

Neck section (*non-spiralling, just gently curved*)
Row 1: Purl 6, sl1, p1, sl1.
Row 2: Knit to end and sl last stitch.
Repeat rows 1 and 2 for 30 rows ending with a knit row (because the next spiral section starts on a purl row).
A: Knit 1 spiral section (rows 1-12).
B: Knit rows 1 and 2 for 17 rows, starting with a purl row and ending with a knit row.

Knit A followed by B, two more times.

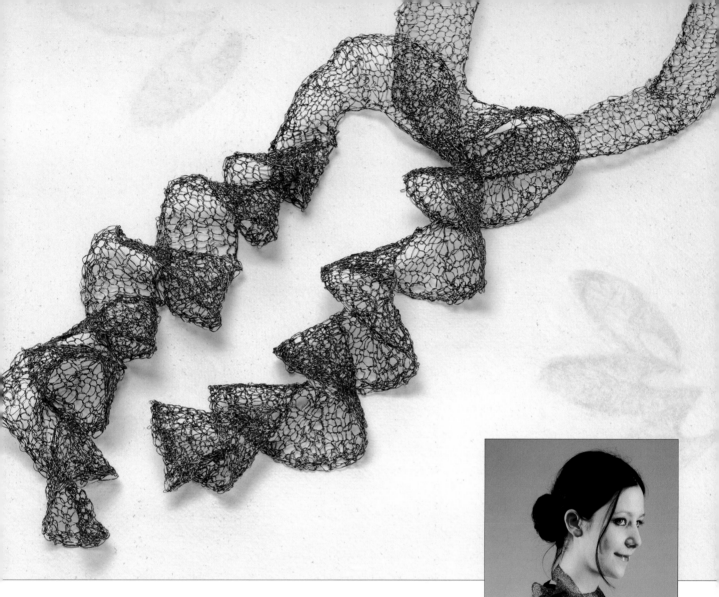

Completing the spiral knitting

Knit rows 1 and 2 for 30 rows, ending with a knit row.

Check the fit of your scarf. Add another pair of A and B rows if you need more length.

Return to knitting the spiral section, rows 1–12, continuously until your work has reached the desired length to complete the other side of the collar, then cast off.

Smooth out your knitting, stretching the edges for maximum curl on your spirals.

Once knitted you can manipulate your finished spiral: twist it round on itself for a tight curl as in the picture above, or pull it out along the short edge for a random wave as shown (right). Knitted spirals can be made more bulky and robust by adding a thread in with the wire as you knit. Try a sparkly knitting yarn as used in the Rainbow Lariat on page 48.

As well as scarves, knitted spirals can be used to decorate hats, bags and even stitched to cuffs for a dandy design.

Healthy Advice

to knit all your life is the goal,
so learn to be kind to yourself

I have learnt over the years to insert yoga breaks and simple exercises when knitting. It is fine to laugh at me, but I promise that these short, easy techniques will protect your body and prevent you from developing repetitive knitting injuries.

Please be kind to yourself and always work in a good light. If evenings are the only time you can knit, invest in a daylight bulb and have it shining from one side, or over your shoulder, on to your work yet away from your eyes. Sit in a healthy position to begin with. That is, sit straight without hunching over.

It is all too easy to work intensively and have the hours spin past like minutes, so make sure you give your eyes and your shoulders regular rest breaks. Set a timer until it becomes a habit.

If you have reached the age (as I have) when you are sure that the wire is getting thinner and difficult to see, go straight to the optician and get the prettiest pair of close work glasses you can. Do not spend months in denial and develop unsightly squint lines to go with the laughter lines.

Look up from your work to the horizon or as far away as possible. Stand up, take a walk around if you can and try the simple exercises below. Always check with your doctor if you have any health issues, to make sure these exercises are alright for you.

When your eyes are tired, place your hands gently over them, then drop your shoulders down and back. Relax as you take some gentle, deep breaths. Continue for as long as you feel comfortable. When you are ready, move your hands away and open your eyes.

It is easy to hunch over when you are deep in concentration so reverse the damage. Sit on a chair where your feet can be placed firmly on the floor, to align your hips roll gently forwards then upright again. Ease your shoulders down and back and take a deep breath. If you are able, lift your arms up high and back again to ease those shoulder joints.

Hunching also constricts the diaphragm and your breathing, so stretch up tall. Take some deep breaths, pushing out your tummy and your chest to reoxygenate.

Terminology

to make life simple knitting has its own language,
if in doubt just return to this page to check

Slip stitch (sl)
To slip a stitch, just pass it from one needle to the other without knitting it.

Pass slip stitch over (psso)
Pass the slip stitch over the knit stitch and off the right hand needle.

Increase (inc)
Knit the stitch where inc is indicated on the pattern, before sliding the loop off the left needle. Bring the right needle into the front of the loop again to knit another stitch into it, then slide the old loop off the left-hand needle.

Decrease (k2tog)
Pass the needle through two stitches instead of one; make the stitch as normal, and slide both the loops off the left-hand needle, leaving you with one new stitch.

Yarn over (yo)
Before knitting the next stitch, bring the yarn right over the right needle and to the back again, then knit the next stitch. The yarn over will have made an extra loop on the needle, which you will use as a stitch on the next row.

Backward yarn over (byo)
First you take the yarn to the back of the knitting between a stitch, then bring it right over the right hand needle to return the yarn to the front.

Yarn forward (yf)
Bring the yarn from the back to the front between stitches. This is used when you have knit and purl in the same row, also for the spiral on page 60.

Yarn back (yb)
This means bring the yarn from the front to the back of your knitting between stitches. This is the reverse of yf, and used for the same reasons.

Cast off
Knit the first and second stitch of the last row, pass the first one over the second one, leaving you with one stitch on the right needle. Repeat until you have only one stitch left. Cut the wire from the spool and bring it through the last stitch.

Index

advice 62
Alice bands 53
amulets *see* talismans

bags 20, 21, 37, 61
bangles *see* bracelets
beads 7, 9
 adding 10–19, 23, 25, 44, 45, 48, 50–59
 chips 16, 17
 crimp 23
 crystal 23, 31
 crystal chips 14–17, 27
 droplets 16–19, 52, 53
 embellishing with 25, 27, 29, 31, 33, 49, 55, 57
 pearls 42, 43
 seed 12, 13, 24–33, 44, 45, 52, 53, 55–59
borders
 beaded 25
bracelets 10–13, 26, 27, 42, 43, 52, 53, 58, 59
braids 7, 44, 45, 52
 layered 46, 47
 with yarn 48, 49
brooches 24, 25, 30, 31, 37
 backs *see* findings

clasps *see* findings
closures *see* findings
collars 54–57
cord 44–47, 50, 51
 see also i-cords
cotton *see* threads
cuffs *see* bracelets

earrings 23
edges
 beaded 25, 29, 57
 binding 39, 40
 joining 11, 26
 oversewing 19, 21, 23

fasteners
 snap 53
findings
 bar clasp 13
 box 51, 53
 end caps 43, 45, 47
 jump rings 15, 17, 23, 29, 53
 necklace clasp 23
 toggles 15, 53
flowers 30–33, 40, 41
 garland 40, 41
 rosebuds 34, 35
French knitting 20, 21, 40–45
 adding beads 44, 45
 layering 46, 47
 with cord 46, 47
 with threads 48, 49

garland *see* flowers
glue 47

hairslides 34, 35, 37, 58, 59
 bases *see* findings
hearts 22, 23

i-cords 50–53

jump ring *see* findings

keyrings 29
knitting *see* wire

lariat 18, 19, 48, 49
leaves 34–41

necklaces 14–17, 22, 23, 44–47, 52, 53
needles 6
 circular 58, 59
 double-pointed 50–53
 gauges 6

padding 28, 29
pendants *see* talismans

pliers 7
 flat-nosed 13, 23
 round-nosed 15, 17, 23, 31

ruffles 54, 58

scarf *see also* lariat
 scissors 6
 spiral 60, 61
sequins 7, 9, 20, 21, 27
shells 27
stitches *see* wire

talismans 28, 29
tension 9
threads 7
toggle *see* findings
tubular knitting *see* French knitting *and* needles, double-pointed
tie *see* lariat

wire 4–6, 9
 coiling 33, 35, 49
 embellishment 28, 29
 ends 9, 11
 flat simple shapes 10–21
 folding 14, 16, 22–29, 35, 52
 gathering 30, 31, 33, 35
 gauges 5, 8
 knitting with 8
 joining lengths 8
 joining sections 41
 lace 56, 57
 layering 22–29, 46, 47, 52, 53
 layers, sewing 14, 16, 23, 24, 26, 28
 spirals 60, 61
 stitches 8
 terminology 63
 threads, working with 9
 three dimensional 28, 29, 30, 31
 twisting 32
 with beads *see* beads
 with cords 45, 47, 51